FOODCHAIN

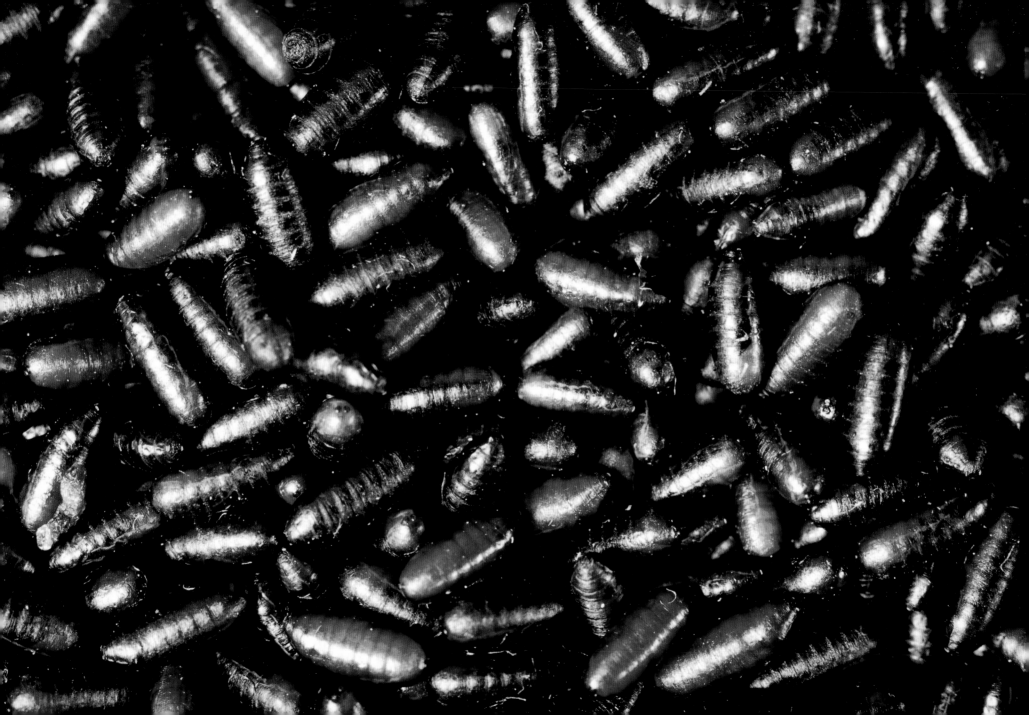

FOODCHAIN

CATHERINE CHALMERS

ESSAY BY GORDON GRICE

EDITED AND WITH AN INTERVIEW
BY MICHAEL L. SAND

ENCOUNTERS BETWEEN MATES, PREDATORS, AND PREY APERTURE

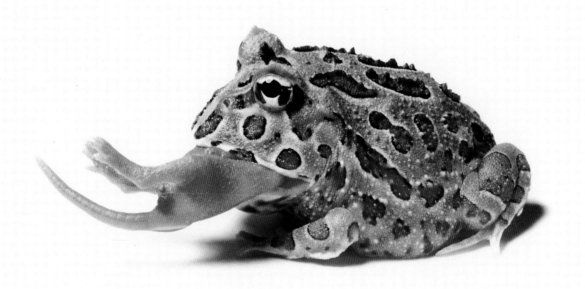

CONTENTS

HAIRLESS

In a little desert town where I had business that fell through, I walked the streets. Downtown was crumbling brick and mortar, signs inviting civic pride and promising renovation. Another sign, felt-tip marker and stencil: "Exotic Snake Show."

Inside I found a flight of cement steps, each step too narrow for my boots, each vertical face eroded as if by a waterfall. There were patches of whitewash on the mint-green plaster walls. At the top of the stairs I found a room empty except for a table where a man stood with a cigar box full of cash.

"Where's the show?" I asked.

He nodded toward the next room, a huge loft. It was empty except for one corner where people stood around a few cages. "Just ask them and they'll show you stuff," the man said.

I paid two dollars and walked over to the cages. A young woman with moussed auburn hair sat in a folding chair. Wound around her arm was a thick strand of black patched with gold like puddles of liquid electricity.

The woman spoke the python's name. When she turned to look at me, I saw a lightning bolt painted on the left side of her face. I looked for the snake's head, finally traced its body to an end which nuzzled under the woman's shirt. The woman looked at me without expectation. She did not blink.

Someone called her from the other room. She held the snake out to me, extricating it from her

clothes, gently raveling. I offered my hands. The python wrapped itself around my arm. The woman ran into the next room. The python was dry and light and alive, the power beneath its hide palpable.

A Chinese take-out carton on the table next to me scooted and rocked. Inside, wallowing in the oily remnants of fried noodles, six infant mice sniffed and twitched. They were pink and blind and naked and not unlike human fetuses. Another one lay in a cage, its side rising with its breath. A tiny python had found it. The lithe black tongue trickled in and out, caressing the pink mouse, tasting, taking its time.

HEADLESS

The mantis seizes her prey and bites it to death, but she chooses where to bite. She usually clips the brain from a moth, because a moth injured in this way stops struggling. A grasshopper is different. If it loses its brain, it may live on for days.

To kill a grasshopper quickly, the mantis strikes for the heart. The heart of a grasshopper is not really one organ, but a yellowish artery strung with seven globular pockets of muscle, like raindrops pendant on a clothesline. The mantis does not have to look for this heart. It strikes a grasshopper from the side, holding it still for a bite that pierces straight to that laundry-line of pumping globules. The breached body yields surprisingly little liquid.

The mantis knows how to take down other predators, even ones that will kill her if she makes a mistake. The brown recluse spider gets a special kind of brain shot. The mantis greets it head-on, seizes its legs, folds them back out of the way, and instead of holding the spider close to gnaw it like an ear of corn, darts in quickly to snip at the brain; she may need two or three tries. This method

keeps her beyond the reach of the recluse's fangs. The spider shrinks in convulsively when its brain is ruptured. The mantis chews straight down, eating the meaty body and leaving a pile of spindly legs.

Sometimes the same treatment works for the black widow spider; other times, when the mantis's size advantage is less decisive, she abandons her usual sit-and-wait strategy and goes stalking. She takes the widow from behind, because the quickest way to a widow's heart is through its back. The half-eaten globose body looks like a rotten plum in her grasp.

The mantis does not learn these methods. As soon as she is big enough to take a particular prey item, she reveals her understanding of its vulnerabilities, her grasp of its anatomy.

Barring an occasional honest mistake, which in her line of work can be fatal, the mantis spares only one creature from the quickest death she knows how to deal. This exception is her lover. Actually, the course of mantid love has almost as many possible outcomes as human affairs do: amicable separation, narrow escape, the murder of the female. A long marriage is the only possibility open to us that is closed to them. Here, however, we are interested in those cases in which the female kills the male. This act may occur before copulation (without necessarily preventing it), during, or after.

The female generally strikes for the brain: she wants his brain injured or, better yet, removed. I would like to tell you she accomplishes this operation with surgical precision, but actually she can be appallingly sloppy about it, leaving half his face intact—and alive—to watch her eat the other half. She may toss the parts about wastefully; she may relieve him of his forelegs before striking her real target. With most prey she's as precise as a sniper with a scoped rifle; with her mate she's as careless as a disorganized schizophrenic with a machete.

After copulation she may, if she needs the calories, eat all of him except for the wings (every

mantis-eater I'm aware of, from cats to birds to insects, hates the wings). But the interesting part is the decapitation during mating. Though she may perform it in an untidy way, it is not a pointless act of violence. Like their grasshopper cousins, mantids are wired so that many of their bodily functions are controlled not by the brain proper, but by a nerve in the thorax. This arrangement explains why grasshoppers don't die instantly from head wounds: the essential functions can go on for a long time without the brain. Roaches, which are also related to mantises and grasshoppers, share this arrangement, and some of them can survive without their heads for weeks. So when a female mantis slices out the brain of her mate, she is not trying to kill him.

The brain may not be indispensable, but neither is it devoid of function. One task it performs for the male mantis is to keep his sexual urges in check. When he loses his head, he loses—well, his inhibitions. He gives every bit of spermatic fluid he can muster. The injury makes him a prolific father. He stays alive, pumping in his sperm, until she has devoured him to the heart.

HEARTLESS

Gina came in with a heart in her hand.

It was a humid ninety-five degrees. I and four or five friends, all of us poor college students, were pooling our resources to come up with a decent meal. Gina and John had gone to the creek and gigged bullfrogs while I stayed behind to clean up the kitchen; it was my policy in those days to wash dishes at least once a month.

Gina had never eaten frog before, and she was struck with wonder at the whole process. She came in from the patio where she and John were skinning the frogs. "Look at this," she said. The frog heart in her hand beat, heaving itself against the air. She poked it with her finger; it kept beating.

"So?" I said irritably, scrubbing at a crusted skillet.

"It's still beating. I didn't know they did that."

"Of course they do. Didn't you take high school biology?" I thought back to my first frog dissection—the stink of formaldehyde, like nausea and cold and lilacs together; the delicate work of chipping away the skull to get the brain out intact, its thick optic nerves anchoring it to the eyes, which were larger than the brain itself. The eyes, when severed, would bounce like rubber balls. In the stomach I found an entire beetle, thick and shining and black and over an inch long. The liver felt like cold velvet.

Of course, the highlight of the dissection was the shock: The teacher touched an electric probe to the thigh muscle, and the leg spasmed. He made a circuit of the limbs: all of them moved to the electric touch. The frog must have been dead for weeks, but when the probe spoke, the muscles still answered.

Gina went back outside, annoyed with my failure to wonder. I went back to my dishes. A moment later I heard the back door open again. I turned and saw my friends, and one of them was holding something wet and red and staring that leaped up and had to be held back. I leaped too, and Gina was happy with my humbling.

It was a bullfrog, of course, big as a football, still scrambling to escape even though it had been gigged and clubbed and skinned and gutted. Its heart lay on the counter beating. Its bloody striated muscles pushed against the hands holding it.

The legs tried to jump out of the frying pan. We served them on a bed of rice. They proved delicious.

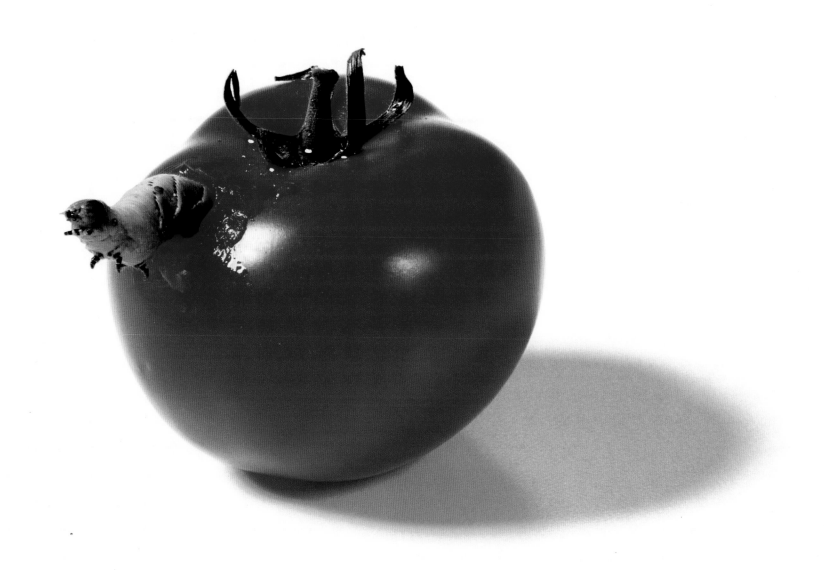

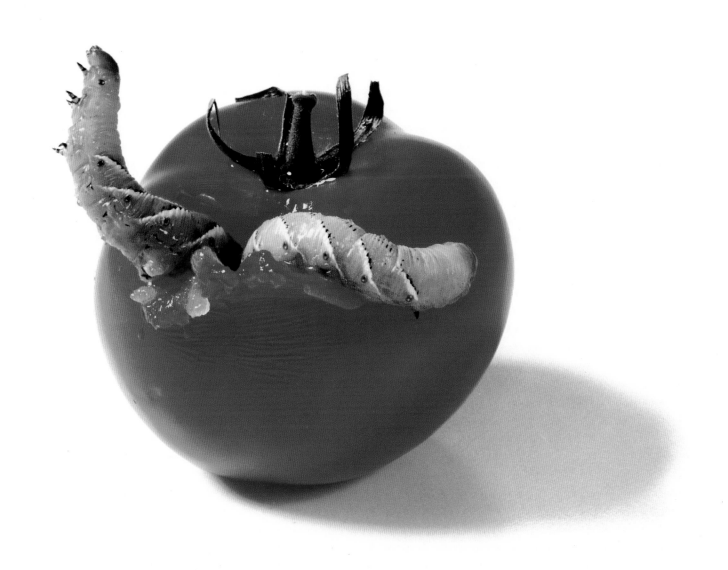

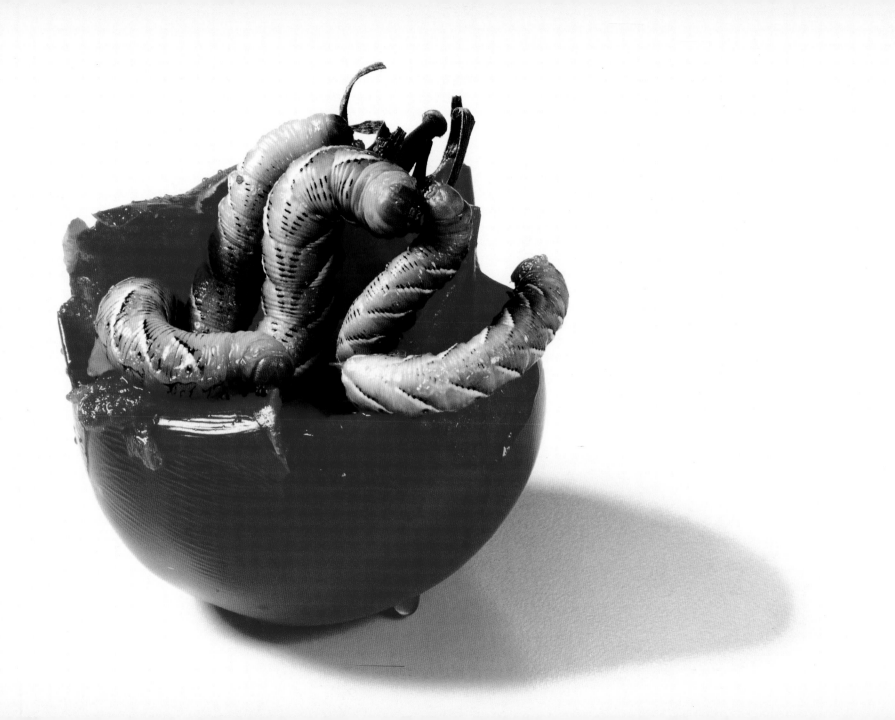

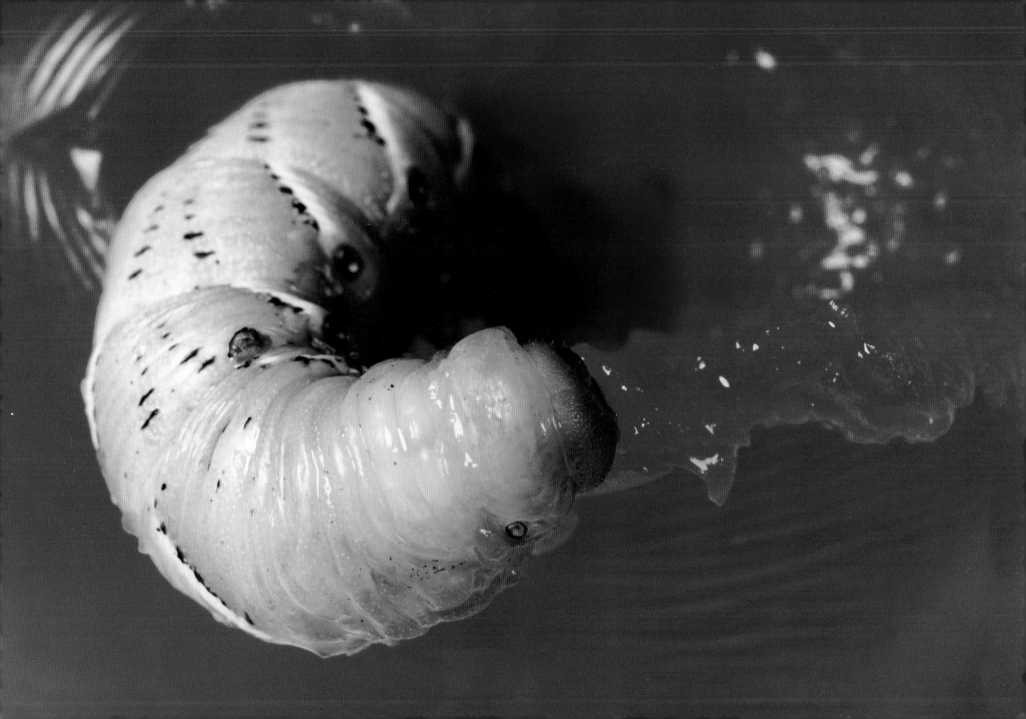

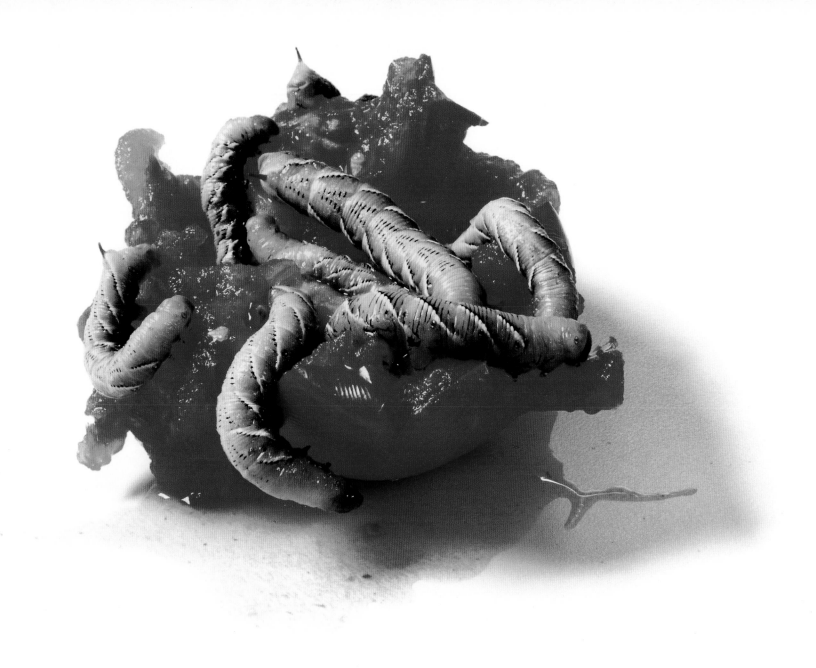

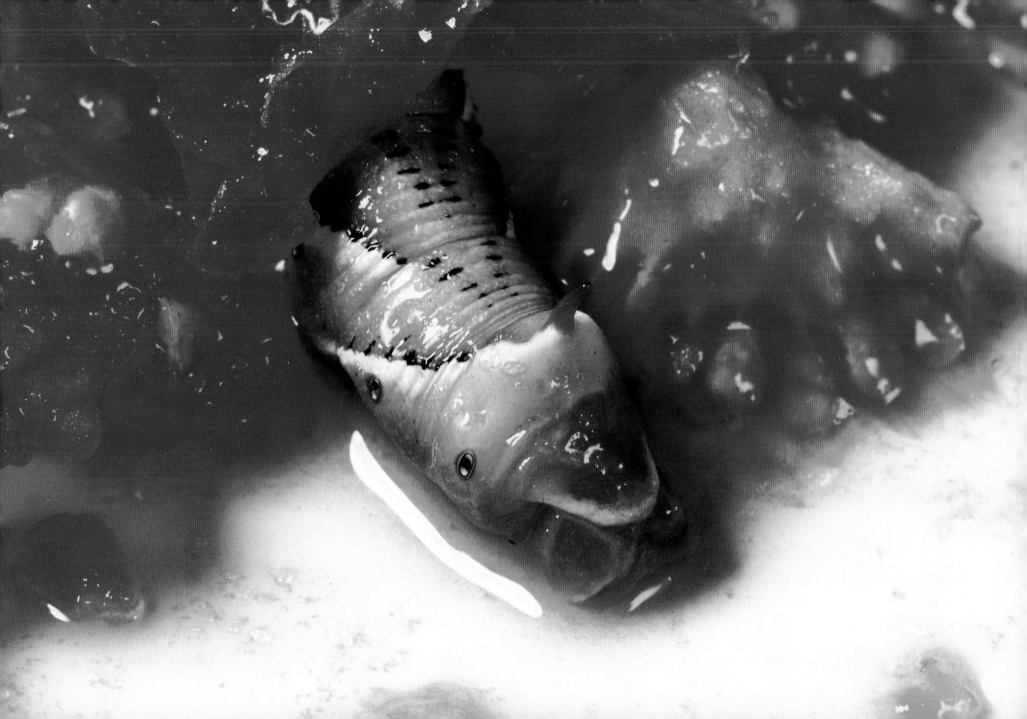

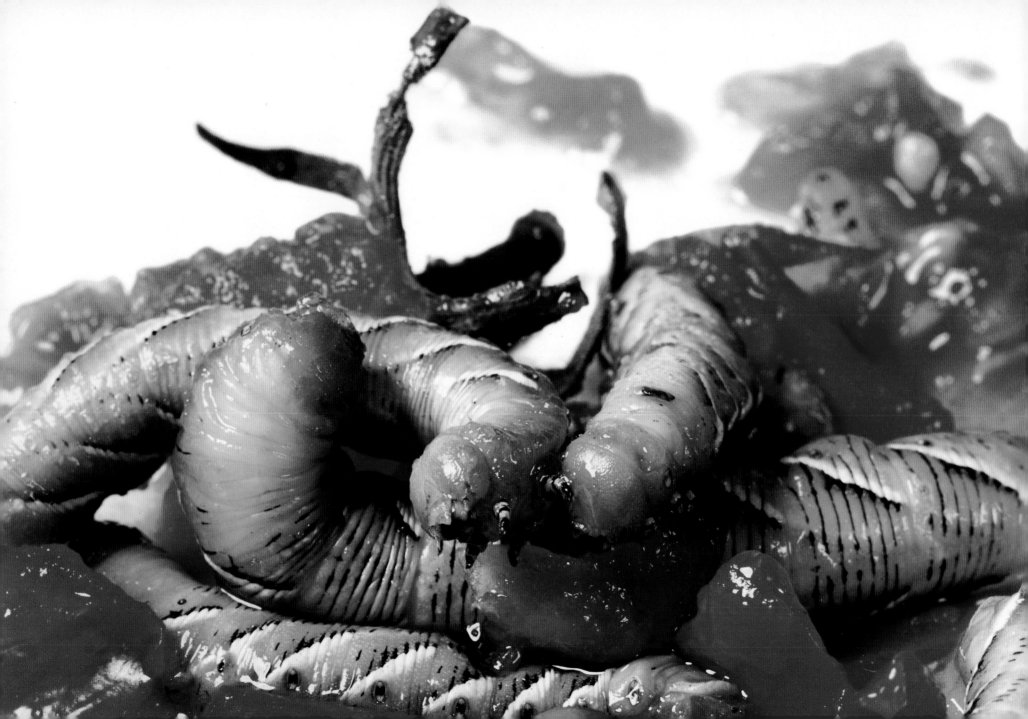

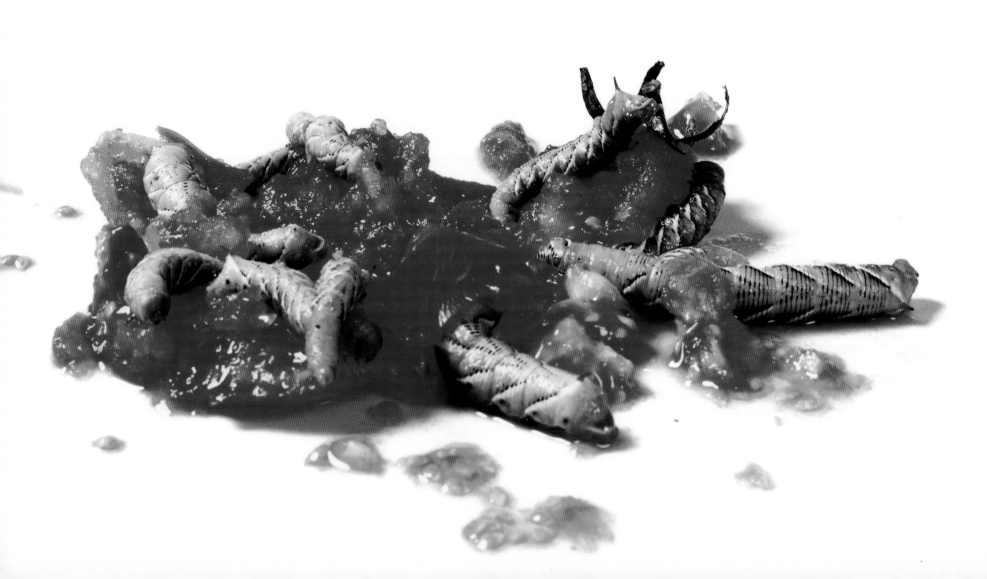

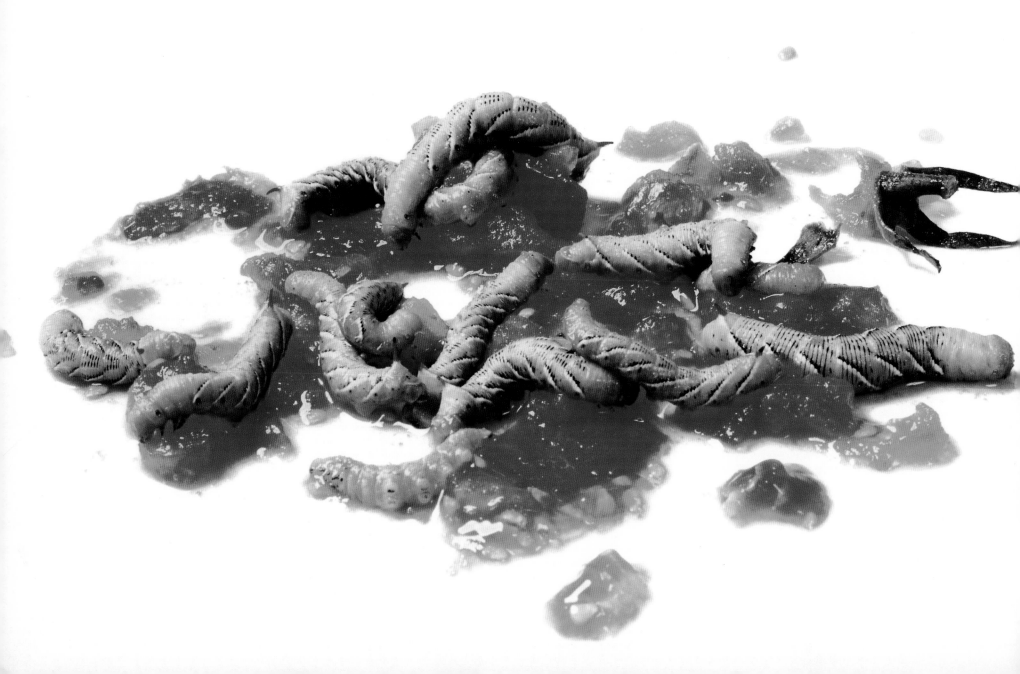

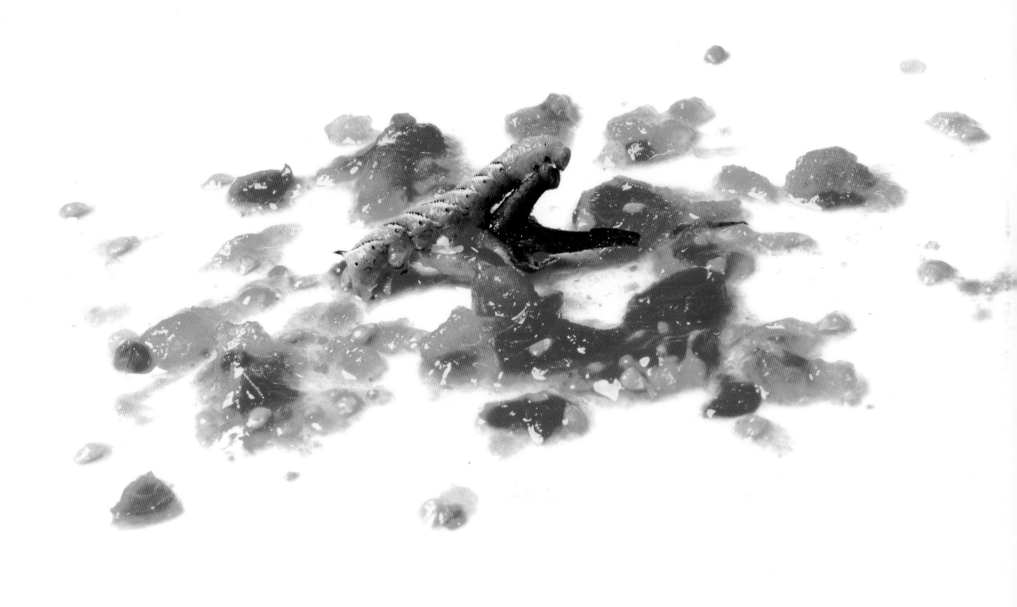

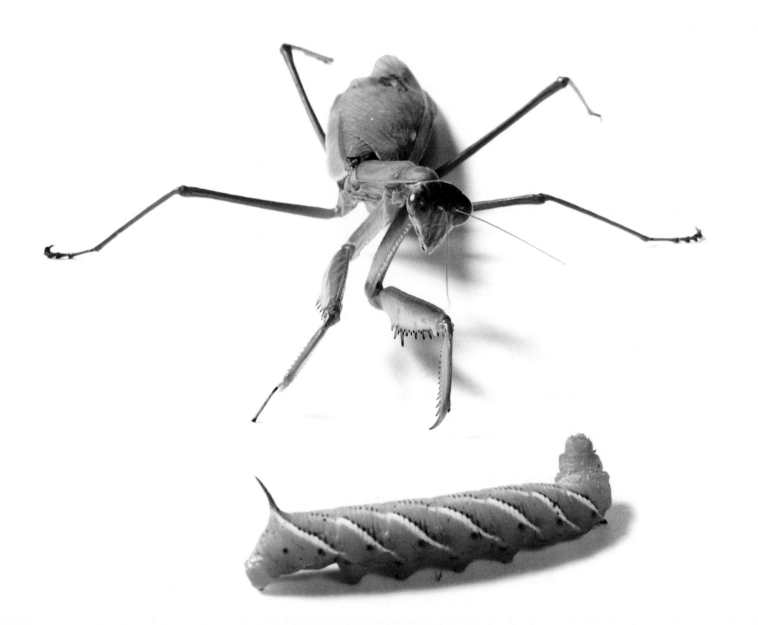

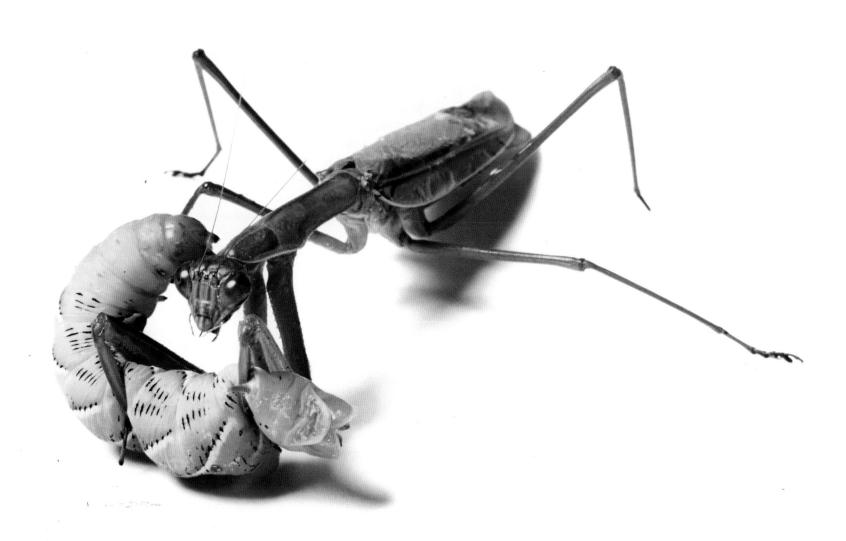

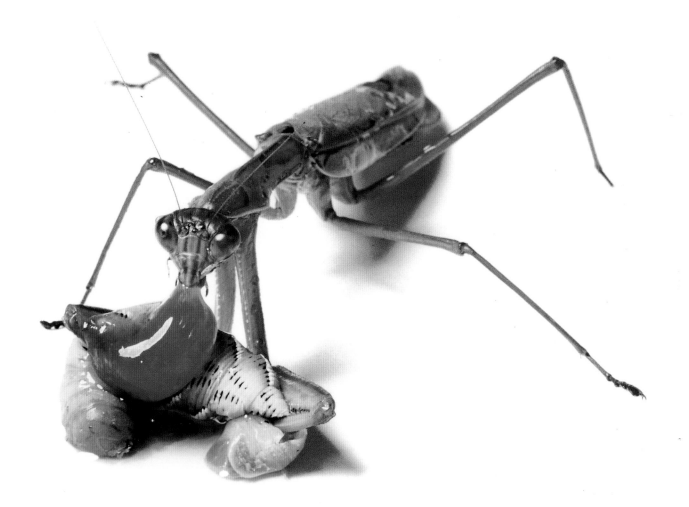

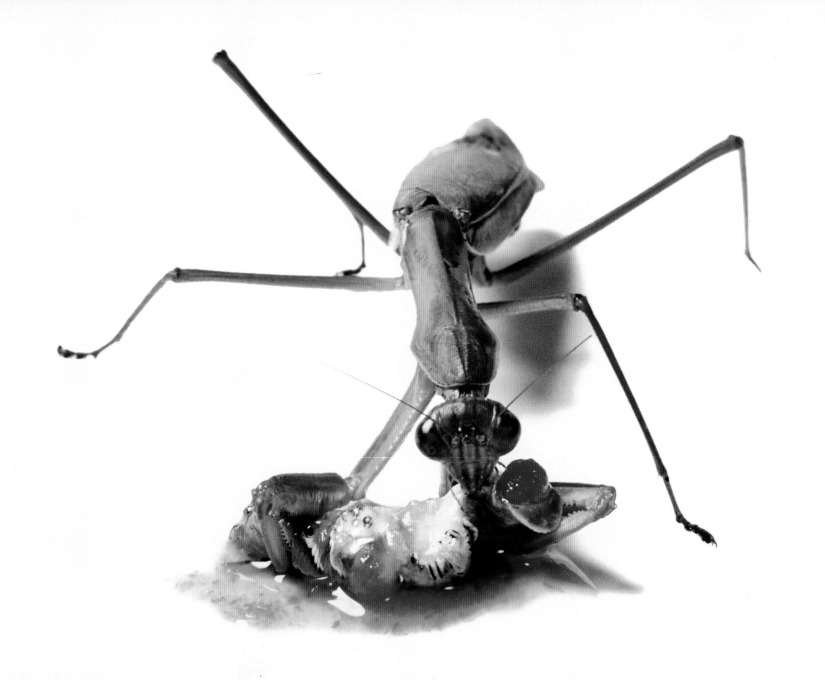

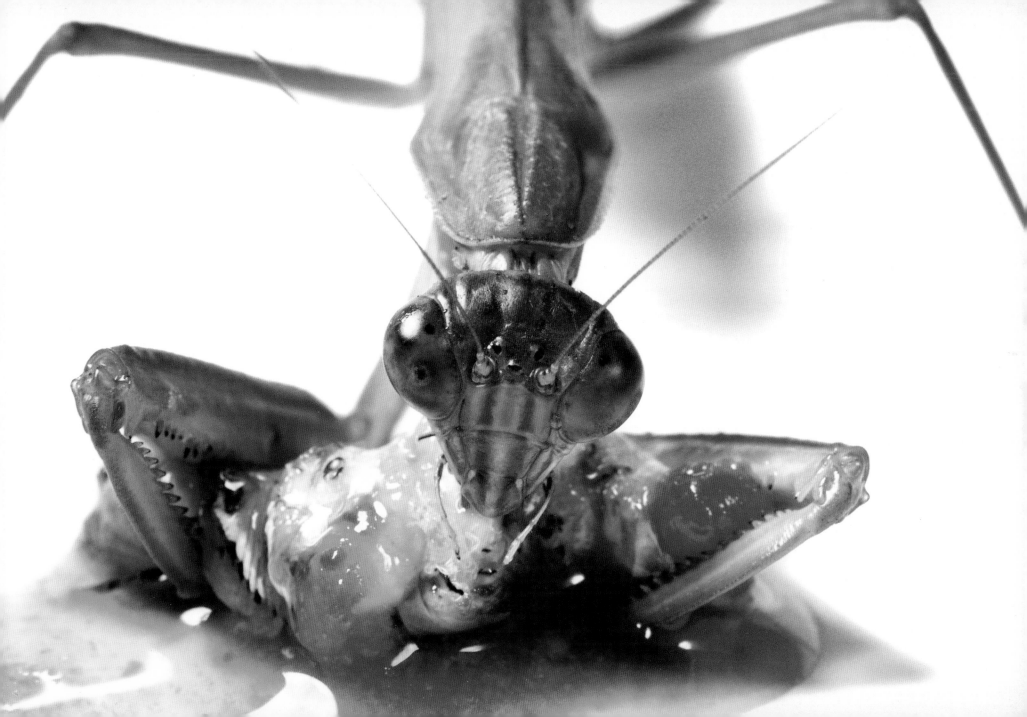

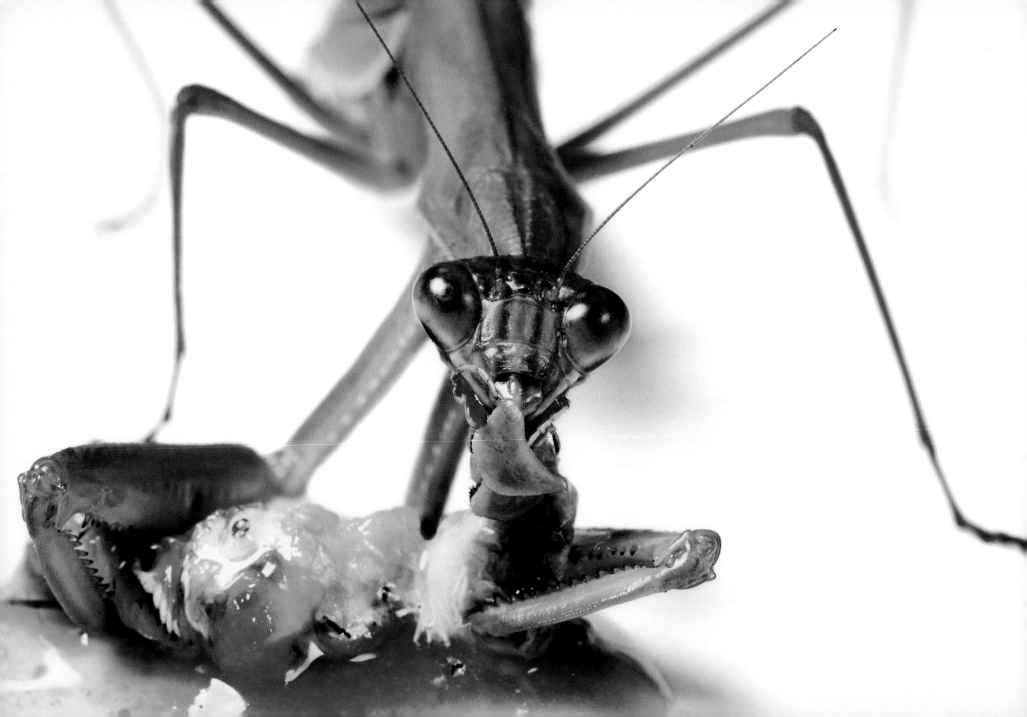

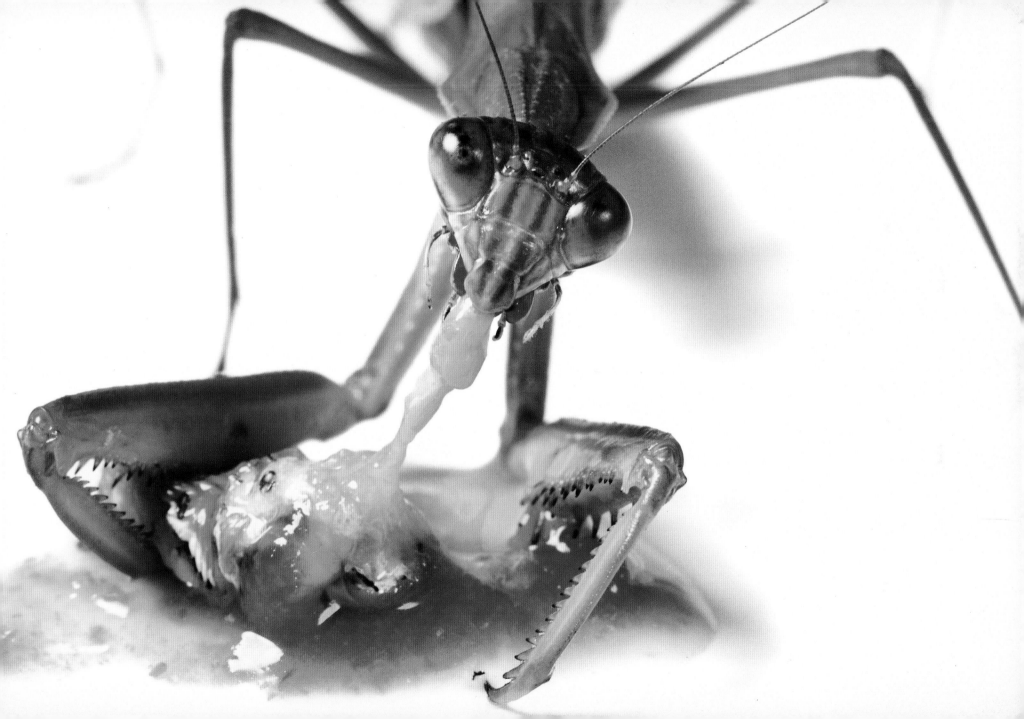

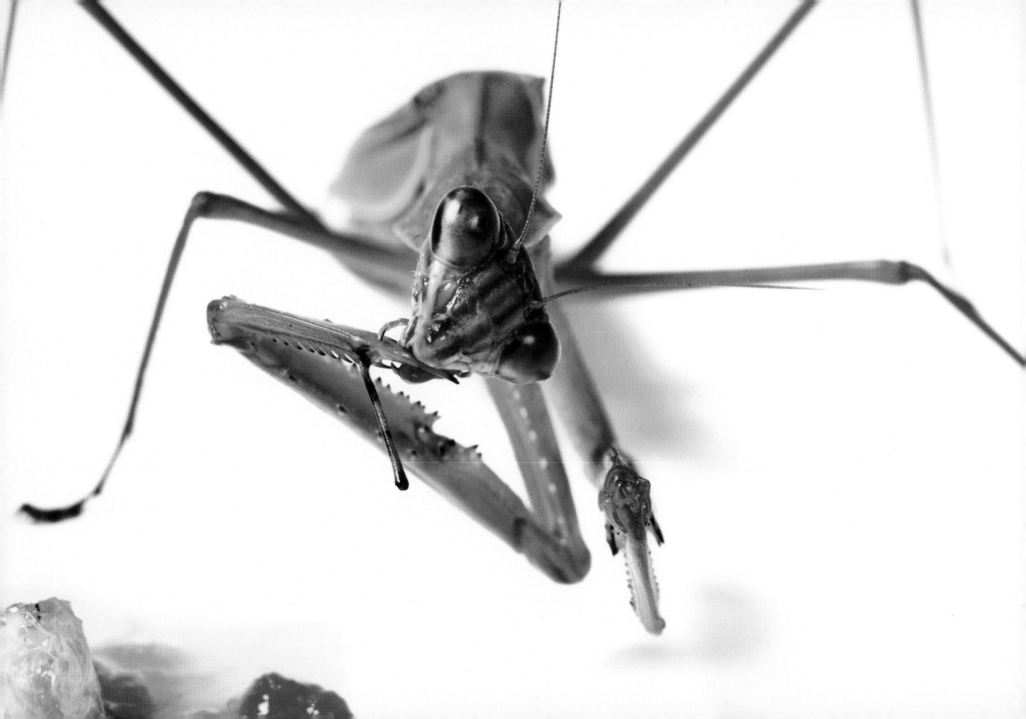

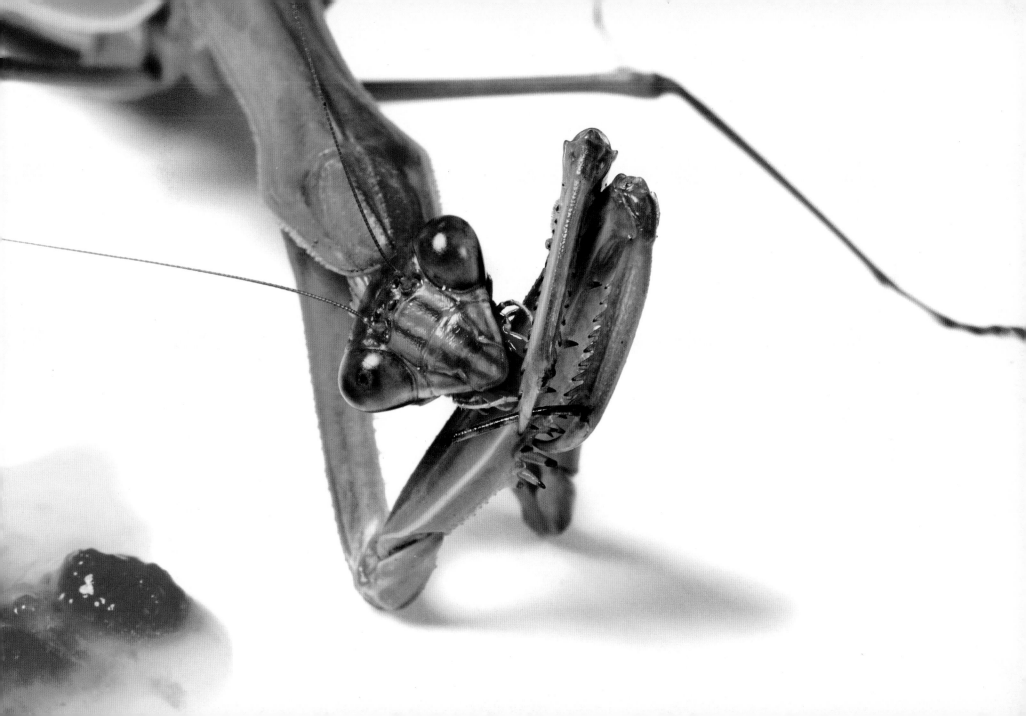

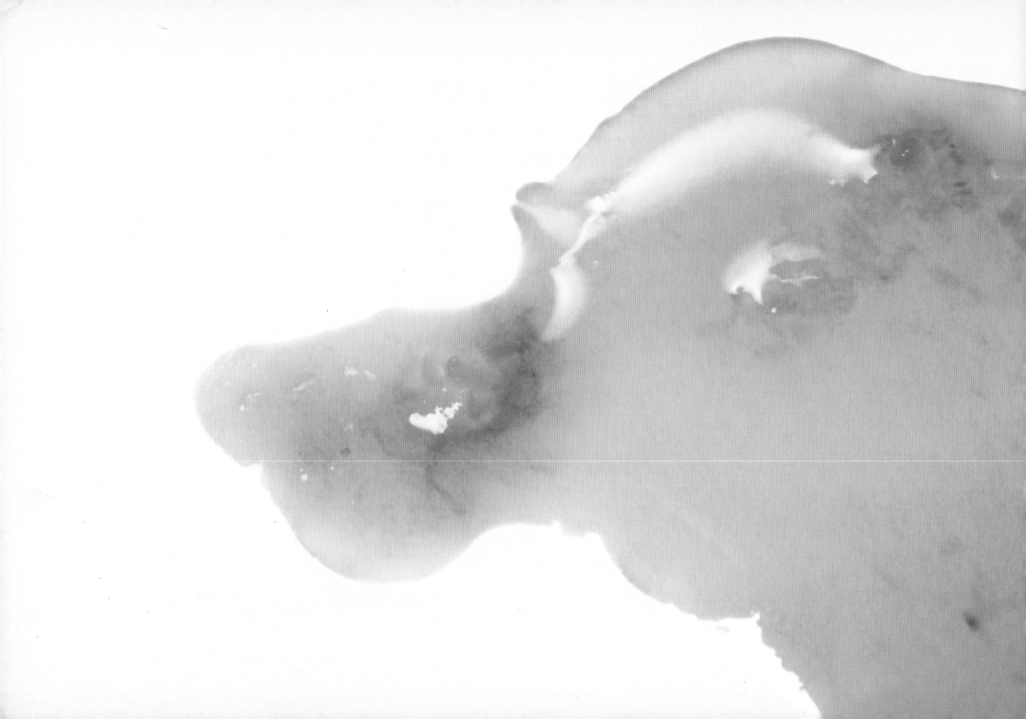

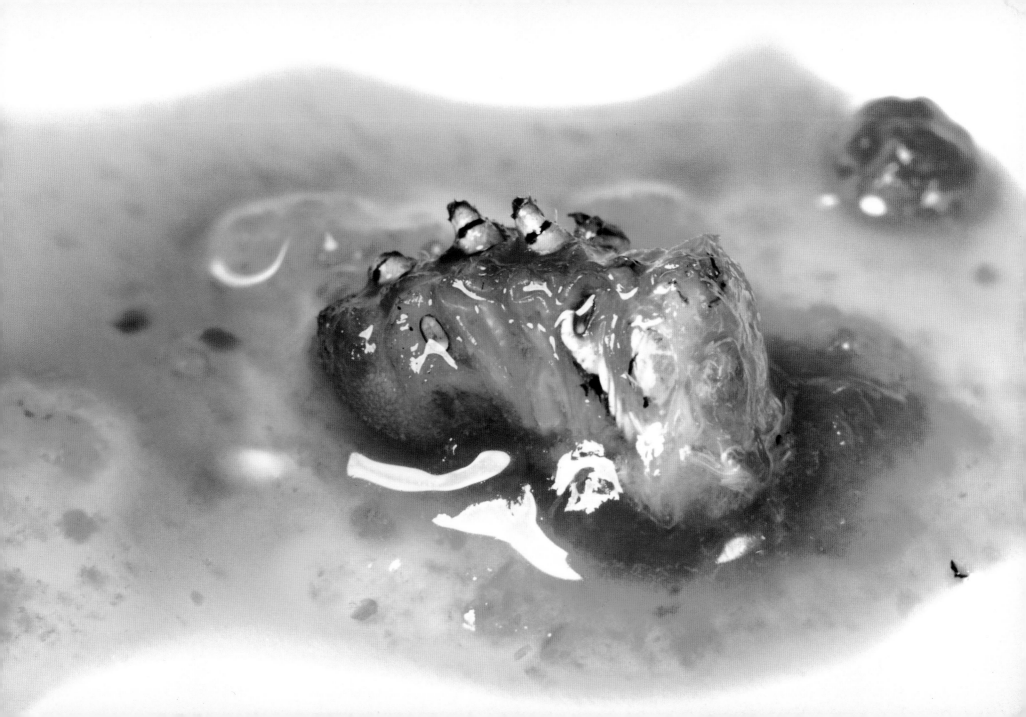

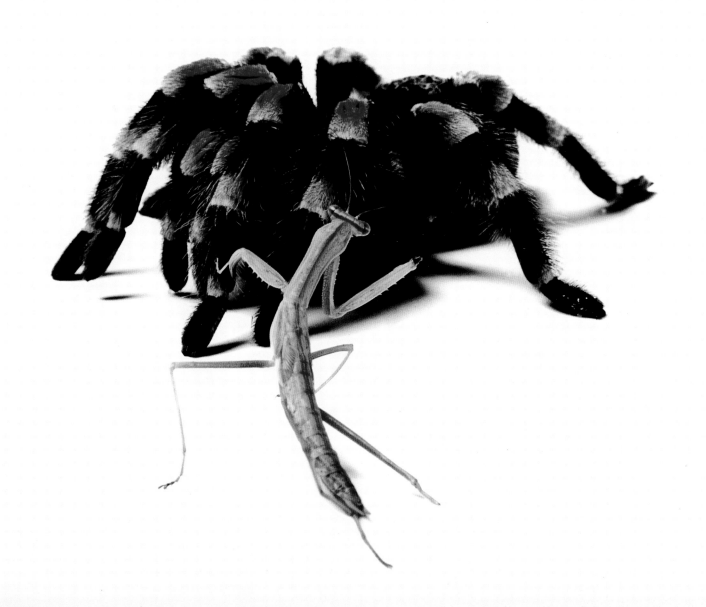

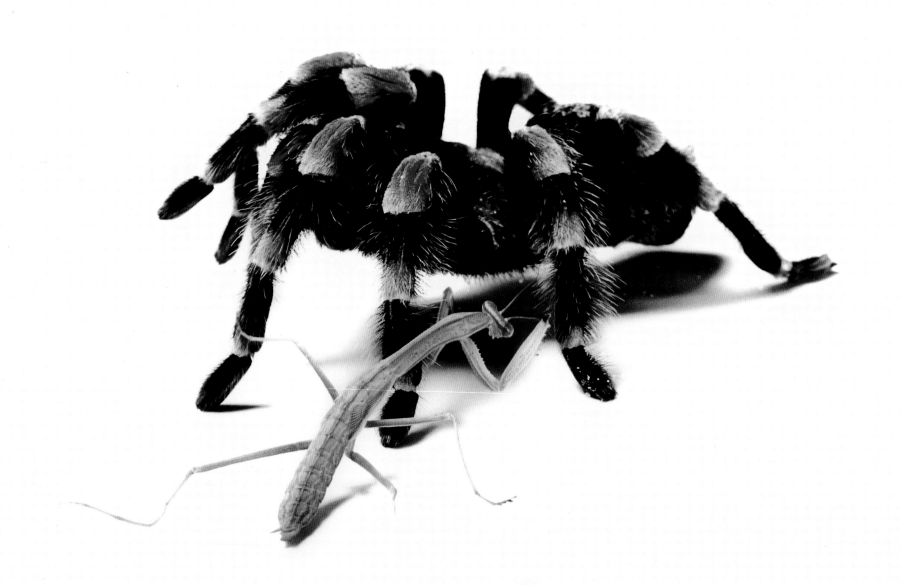

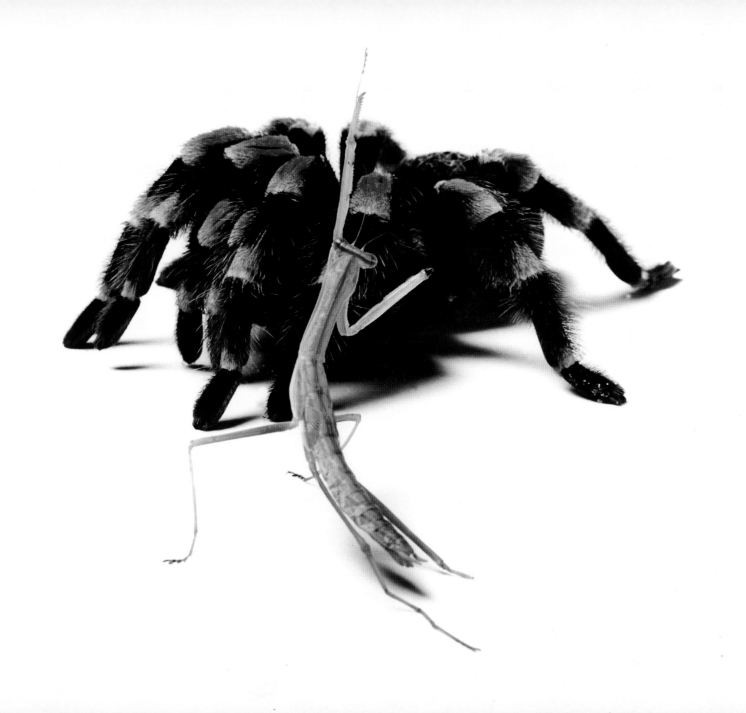

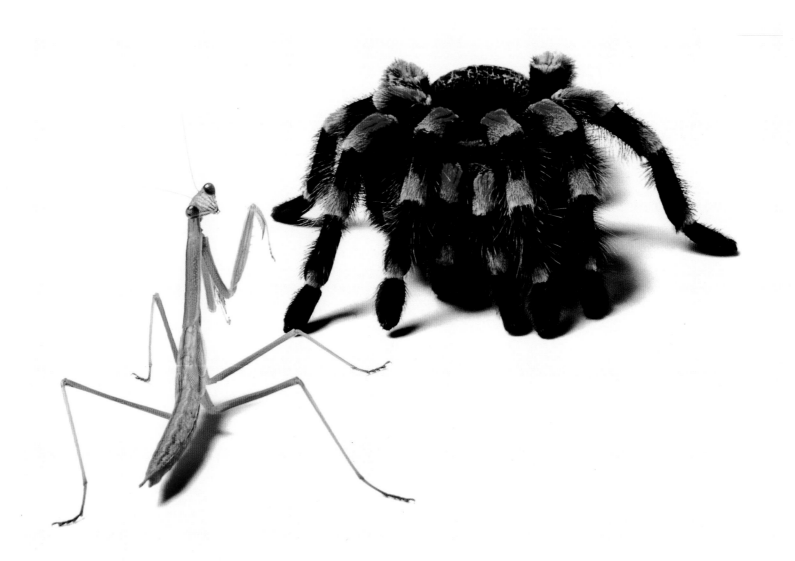

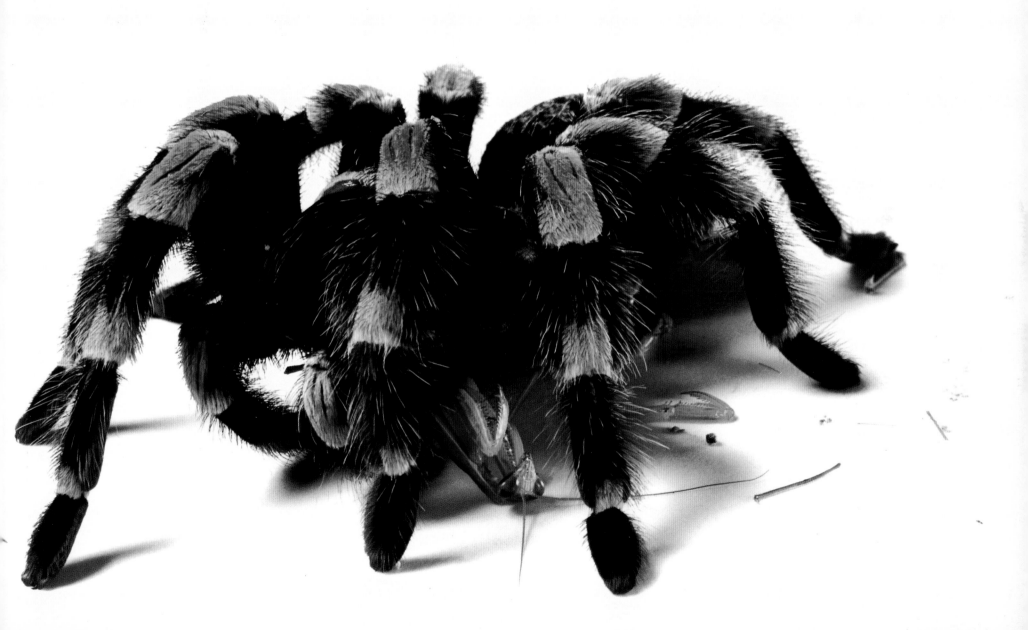

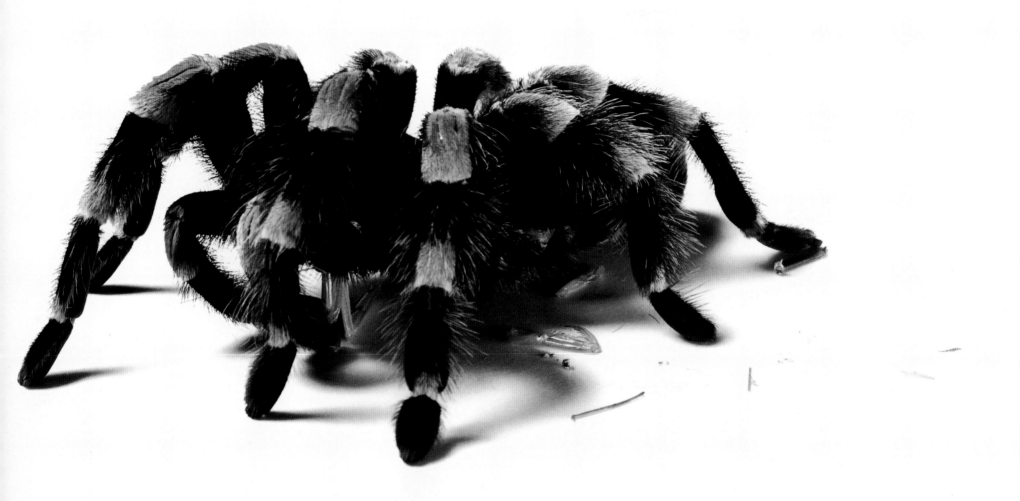

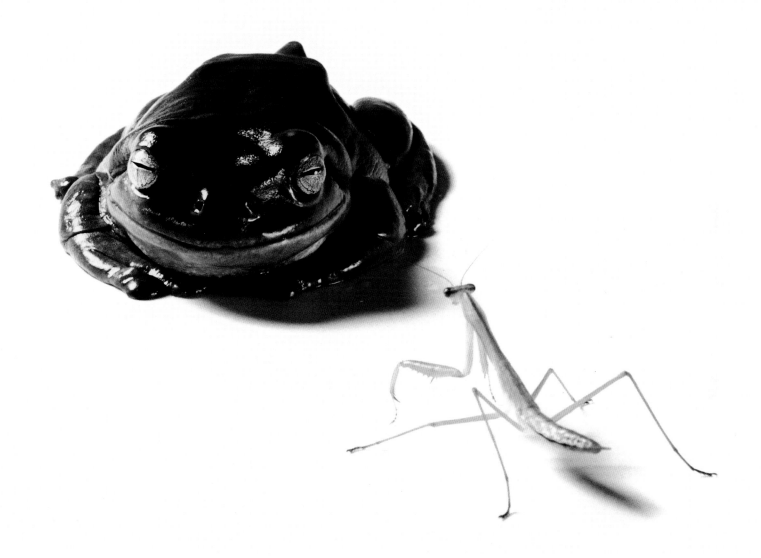

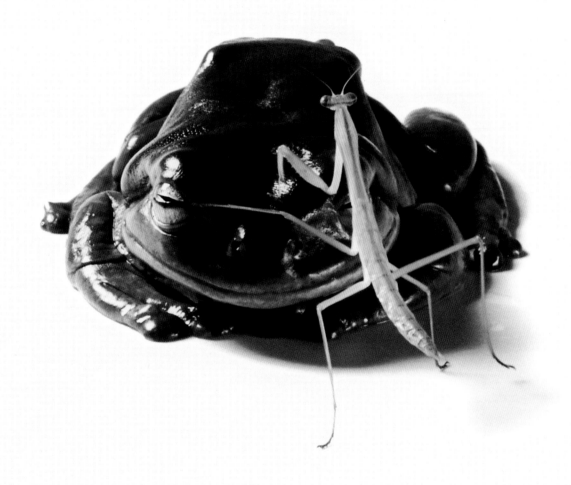

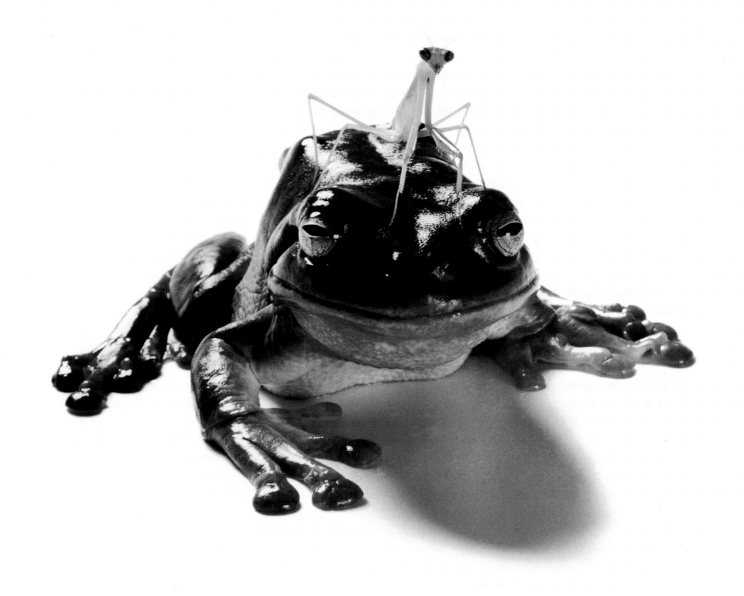

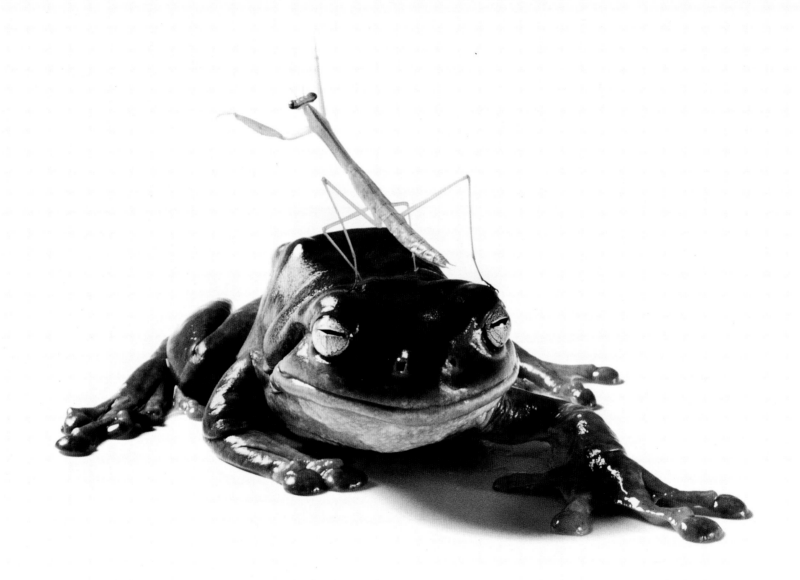

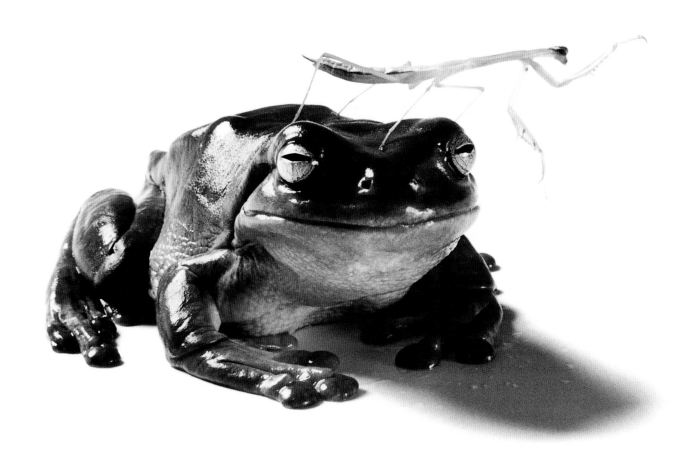

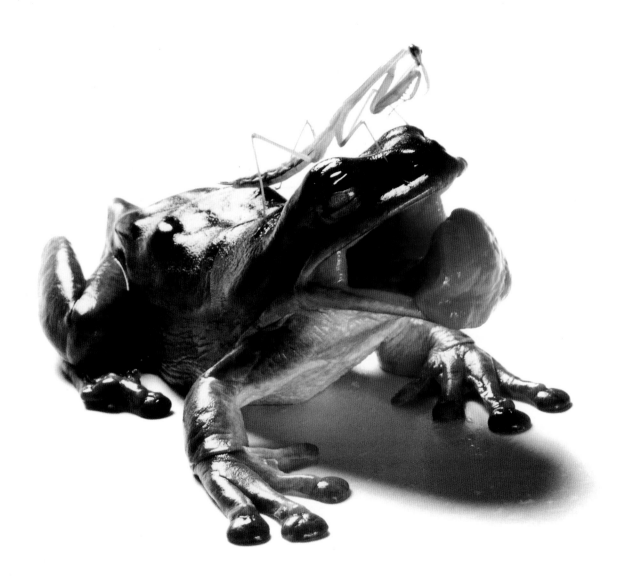

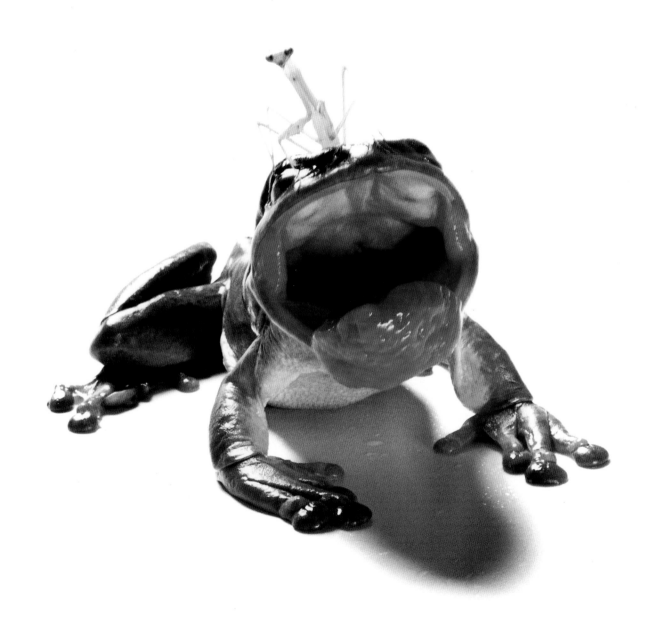

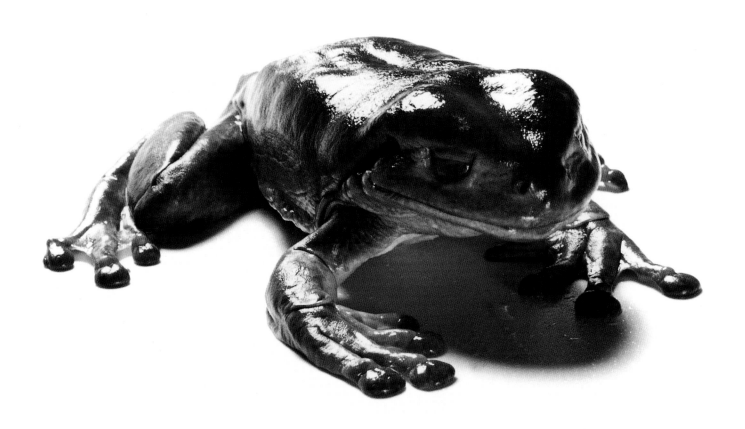

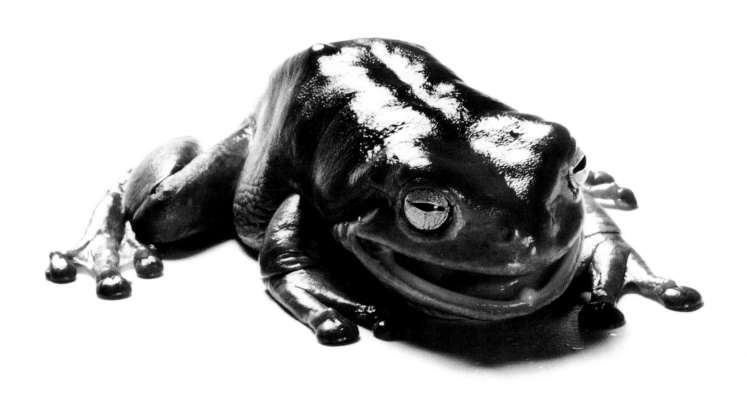

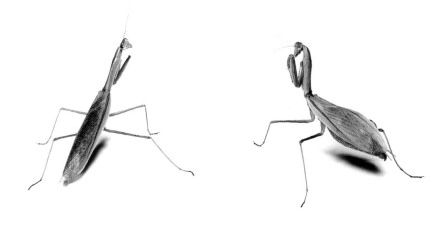

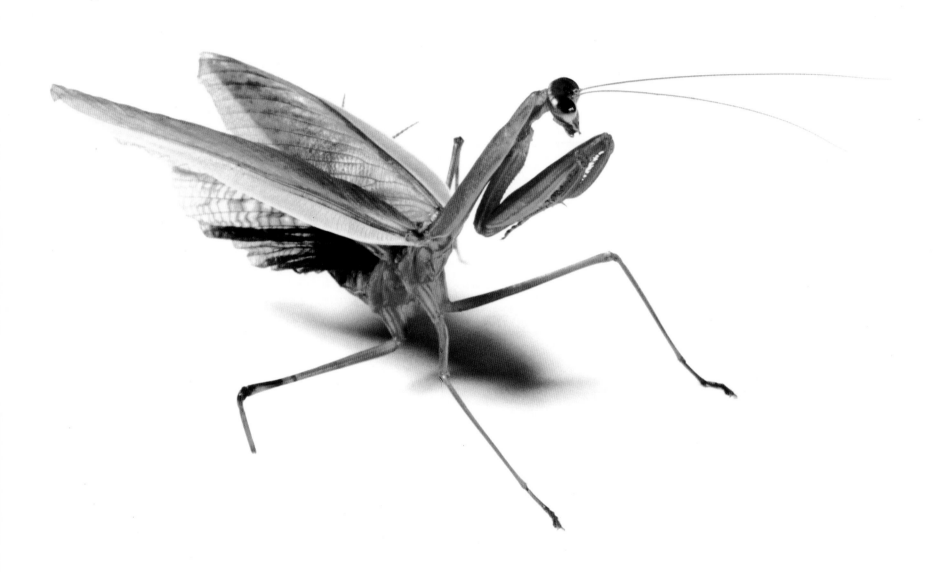

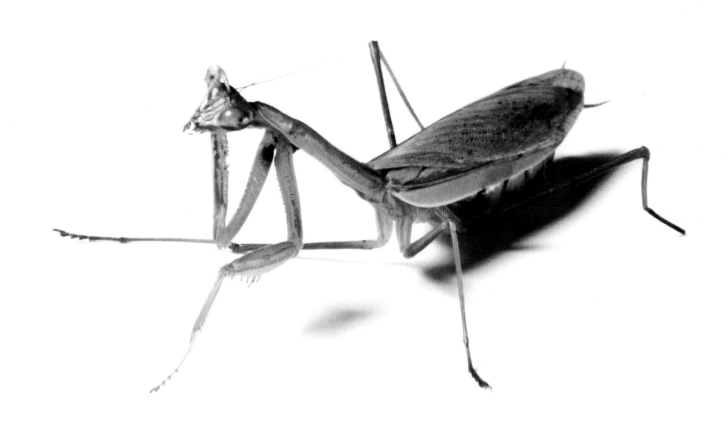

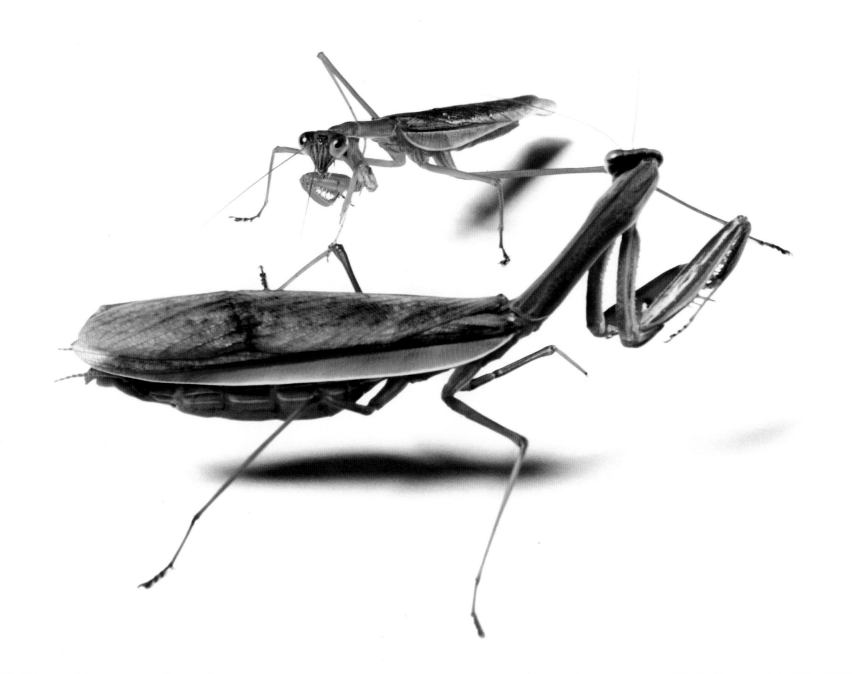

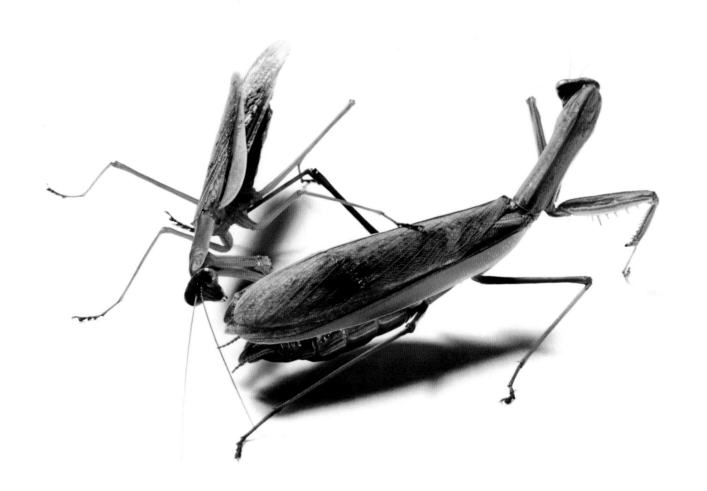

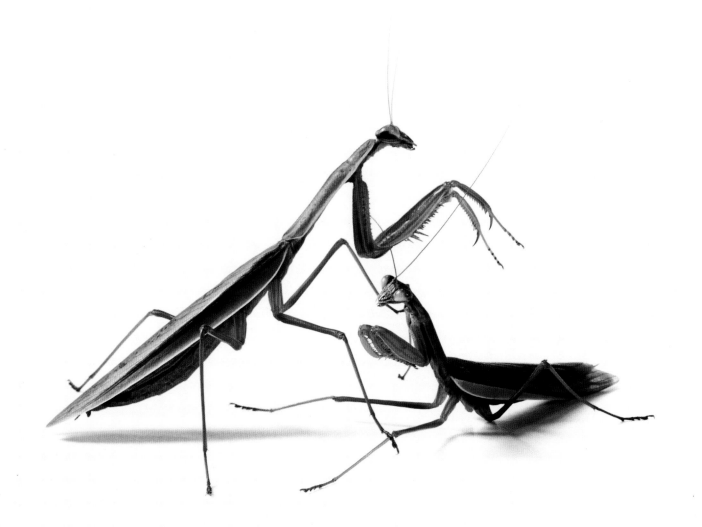

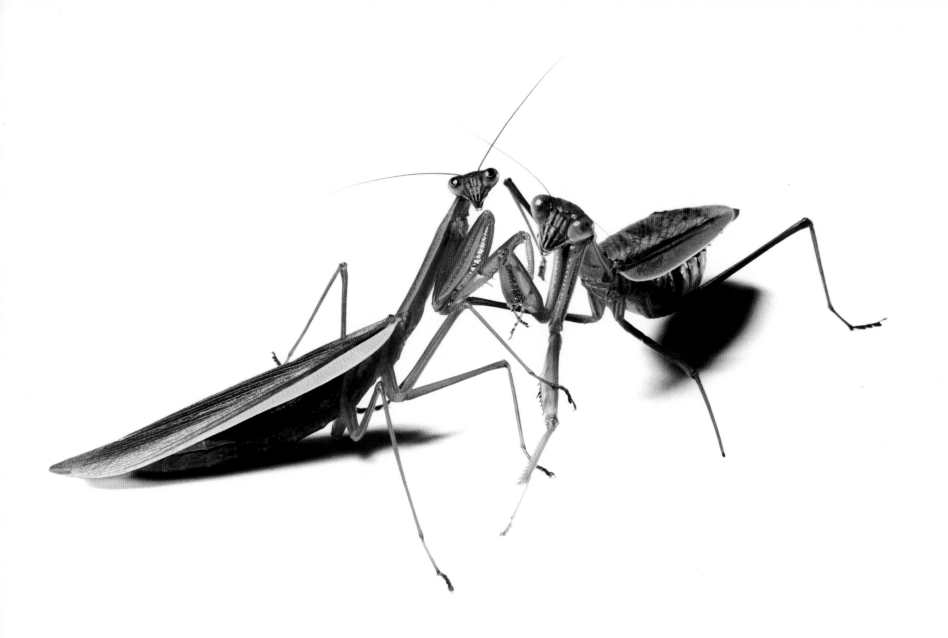

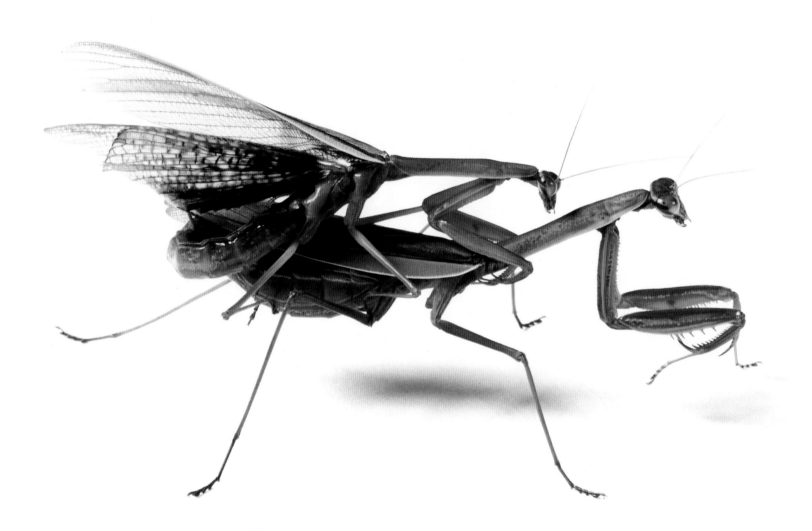

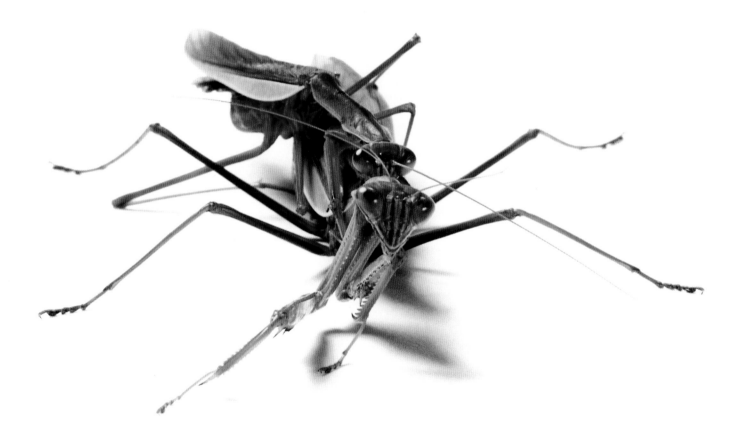

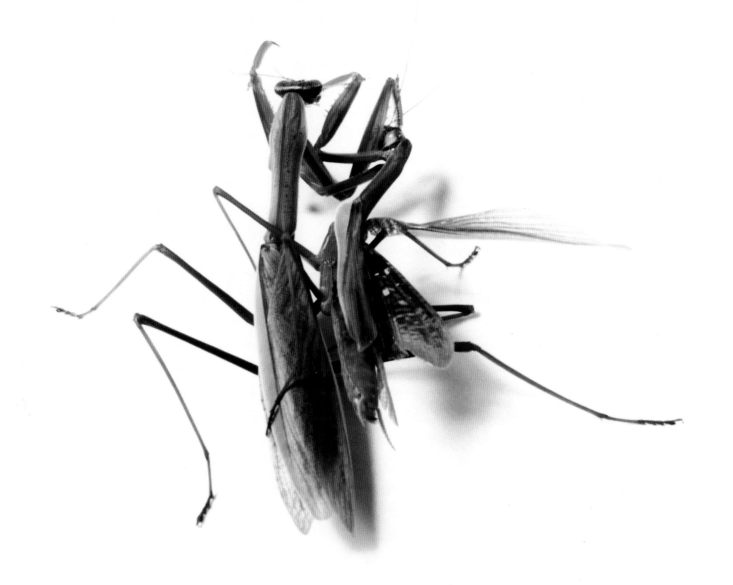

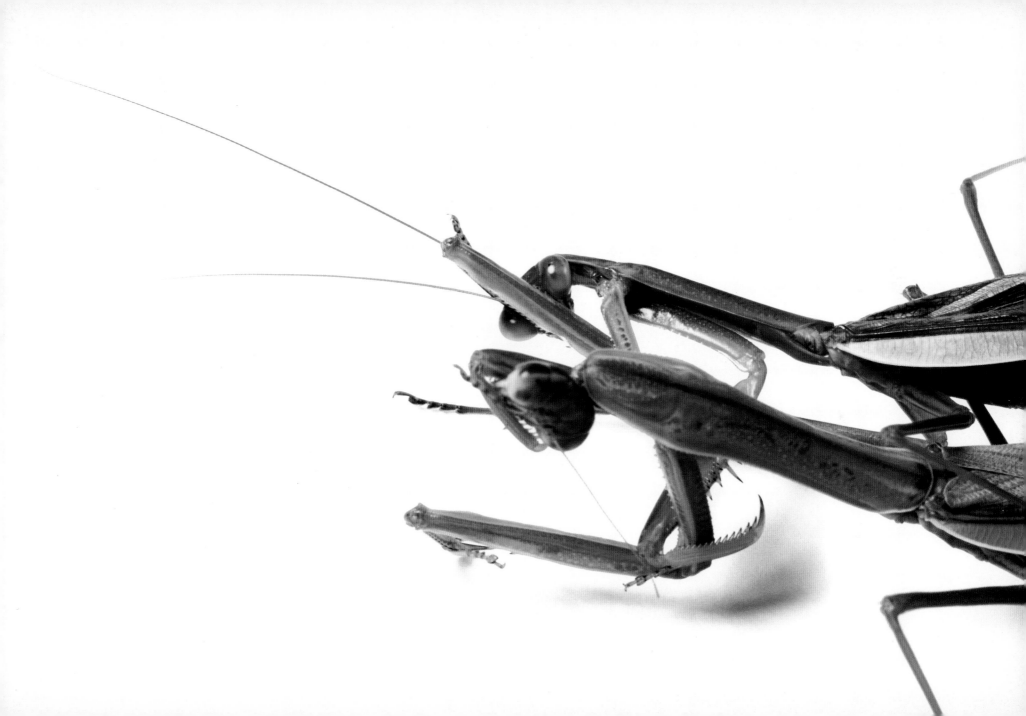

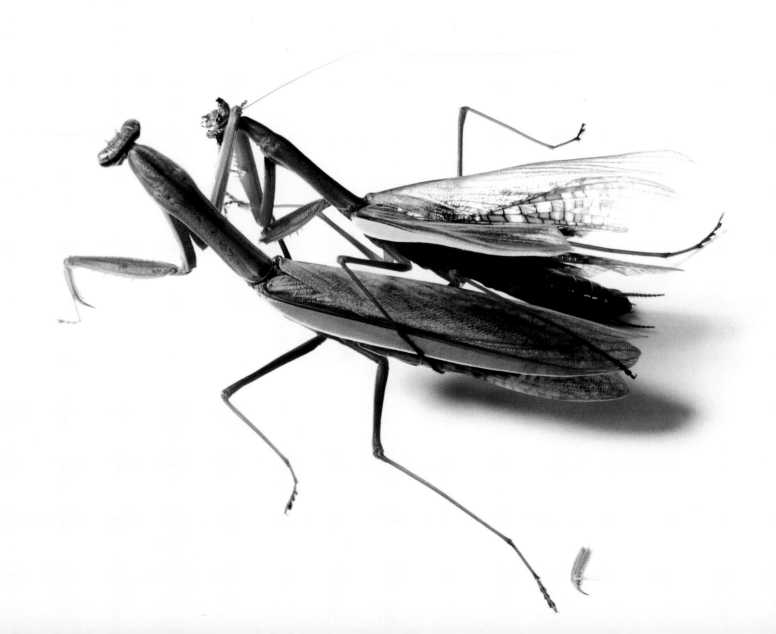

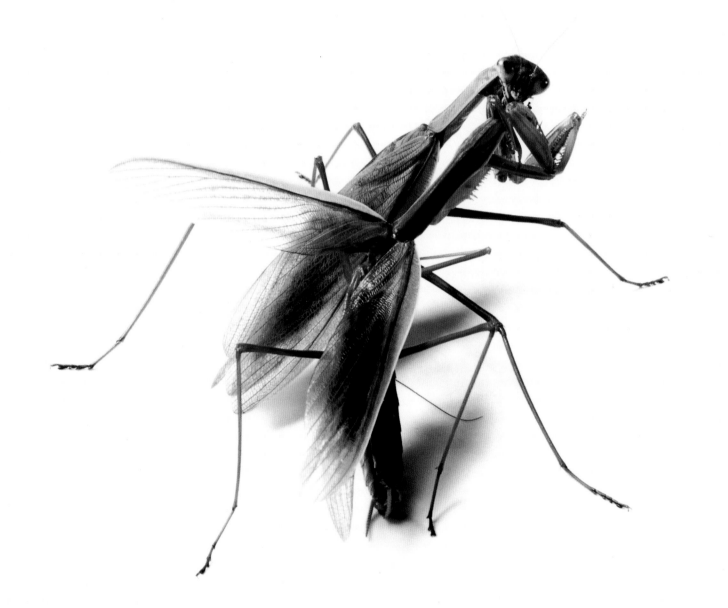

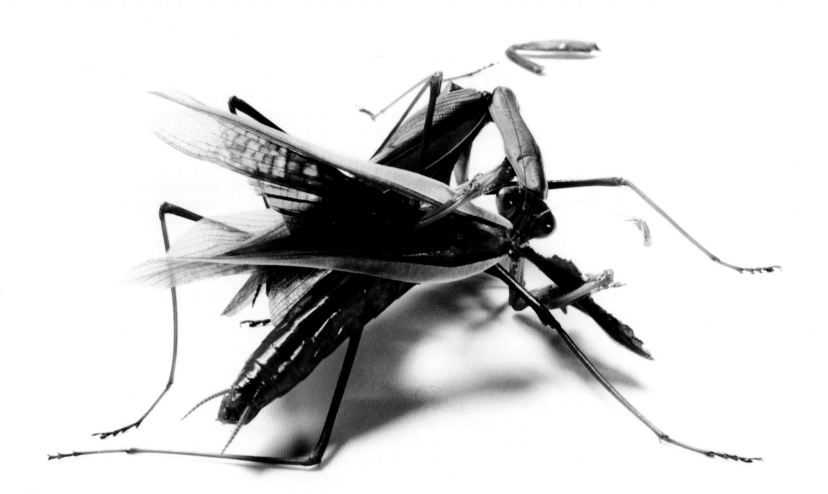

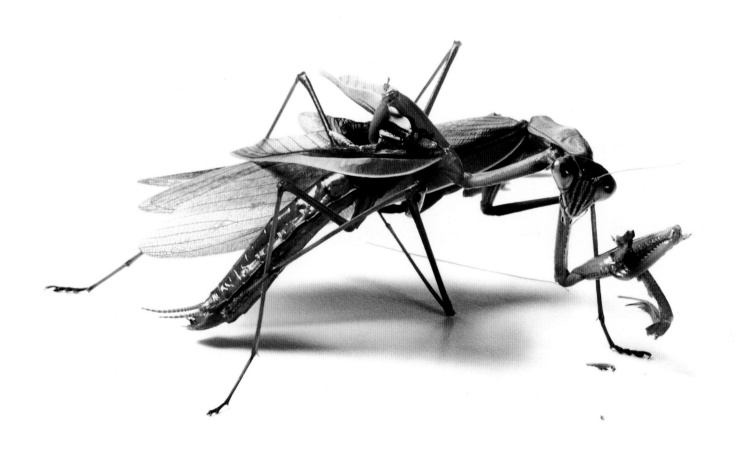

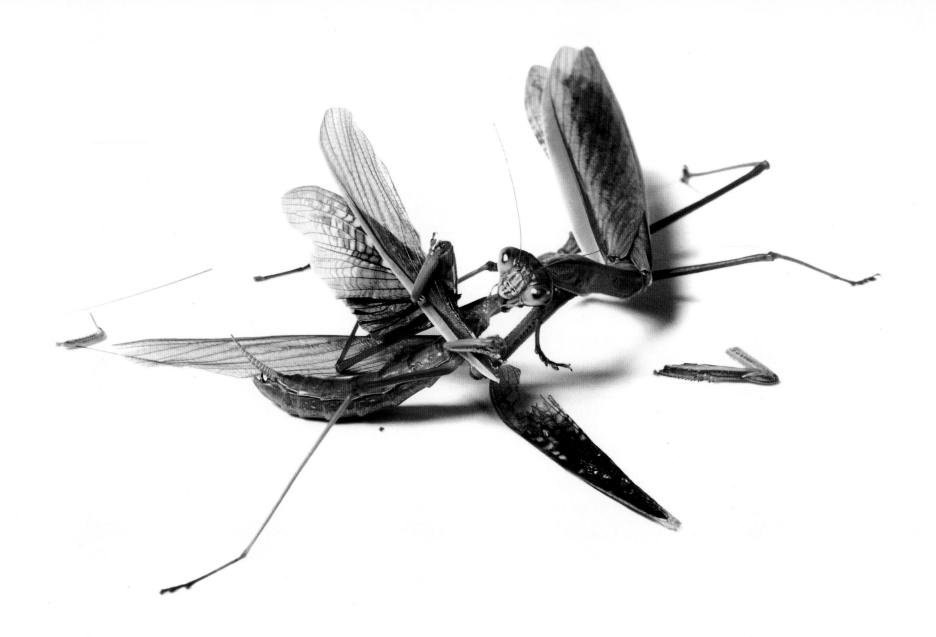

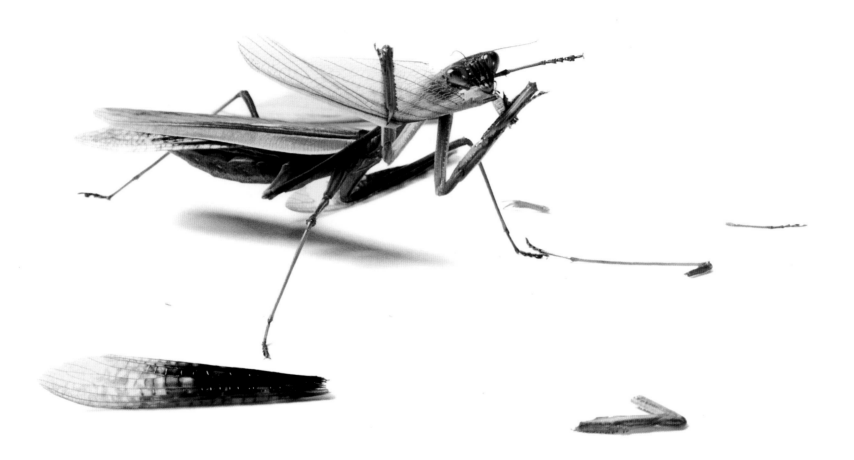

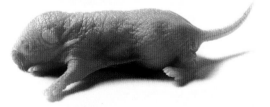

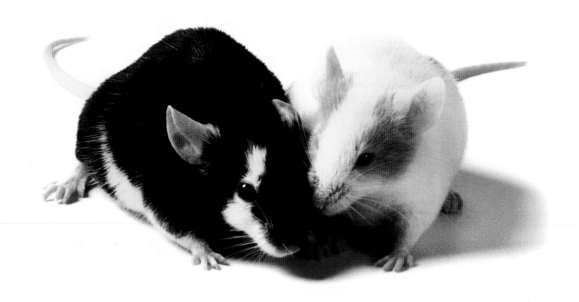

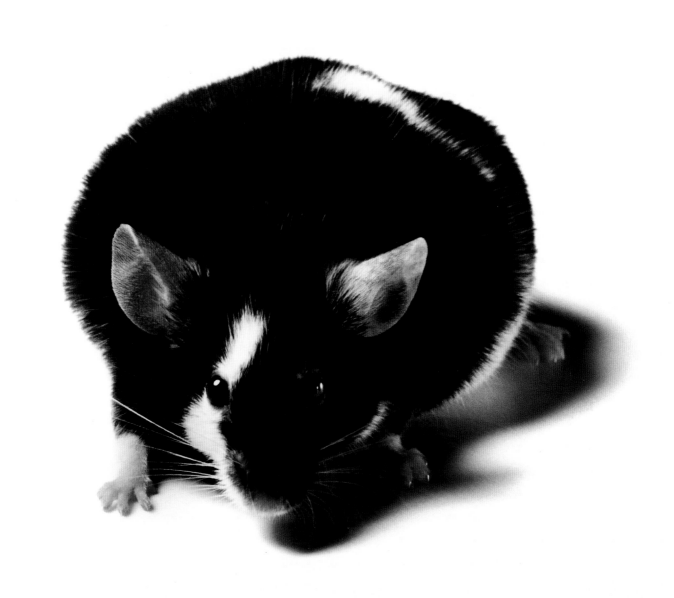

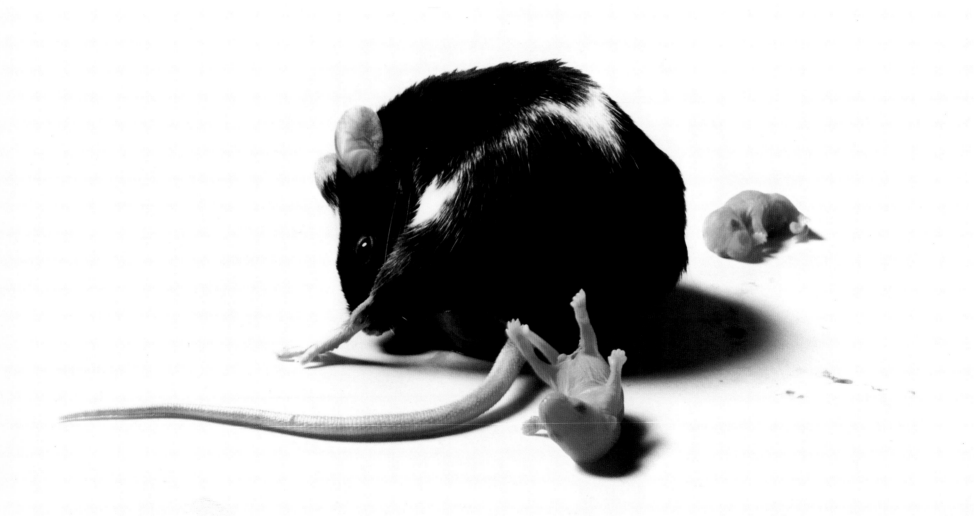

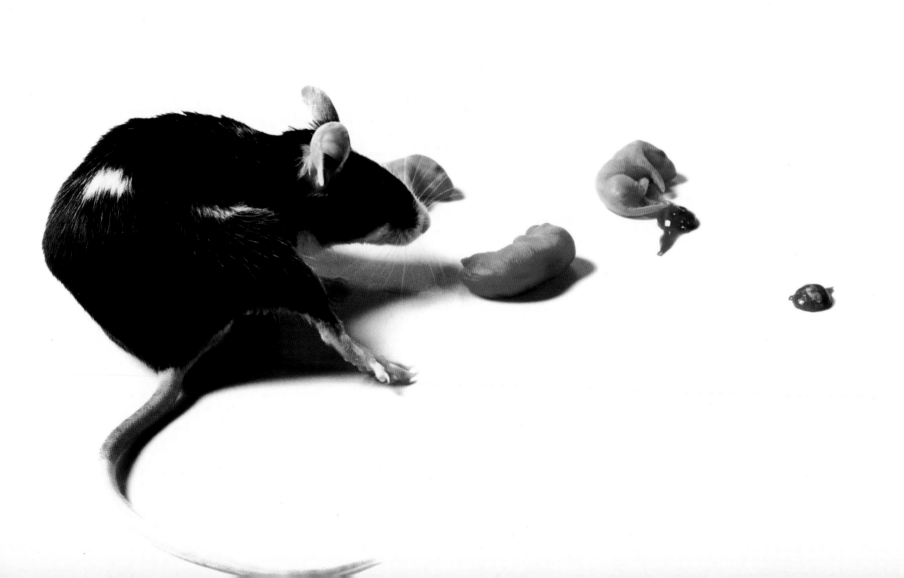

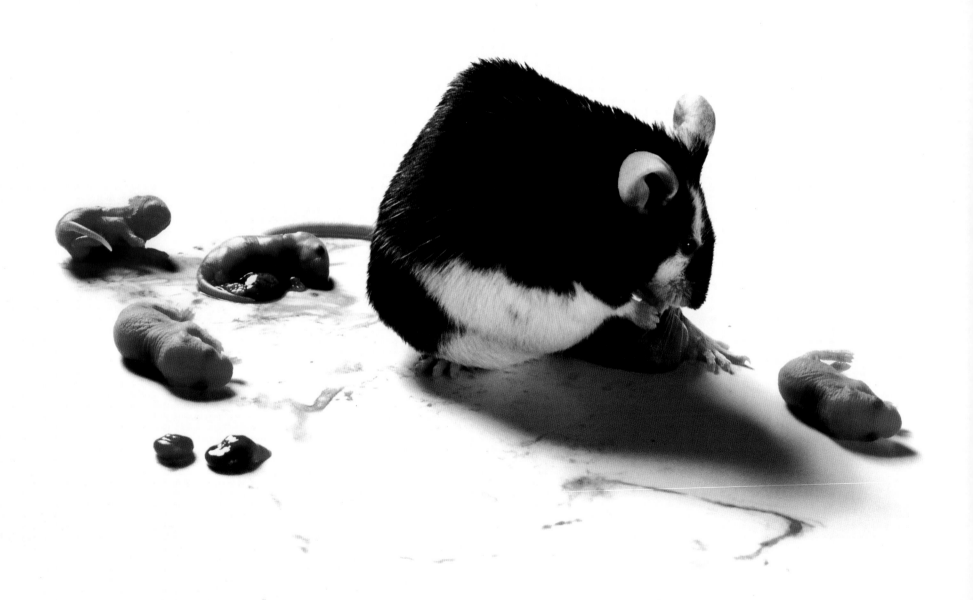

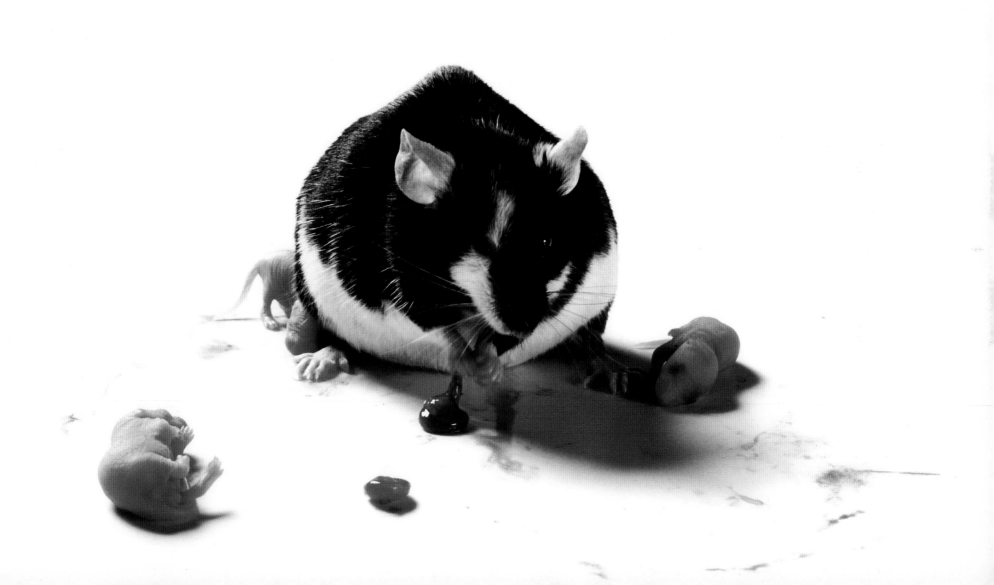

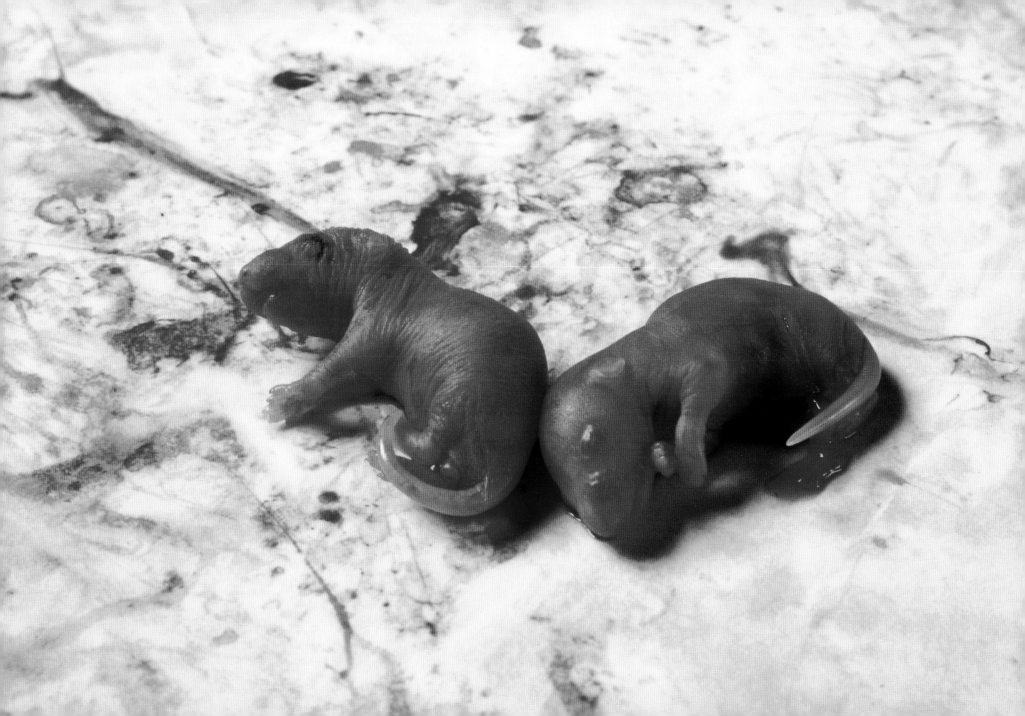

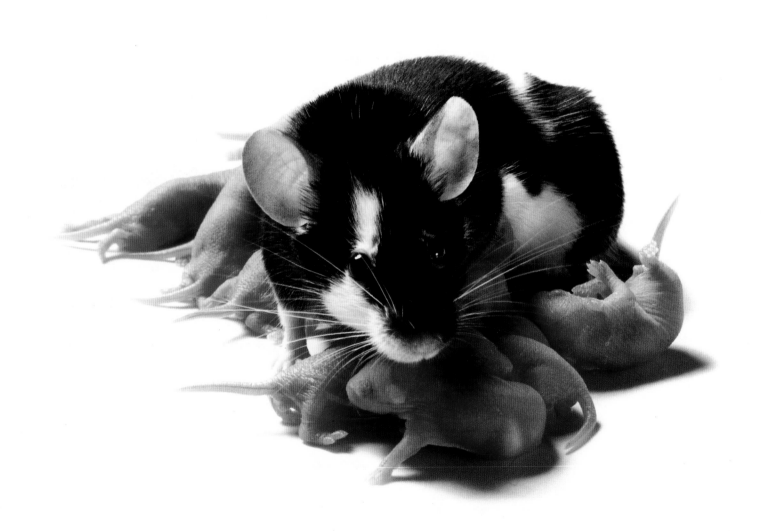

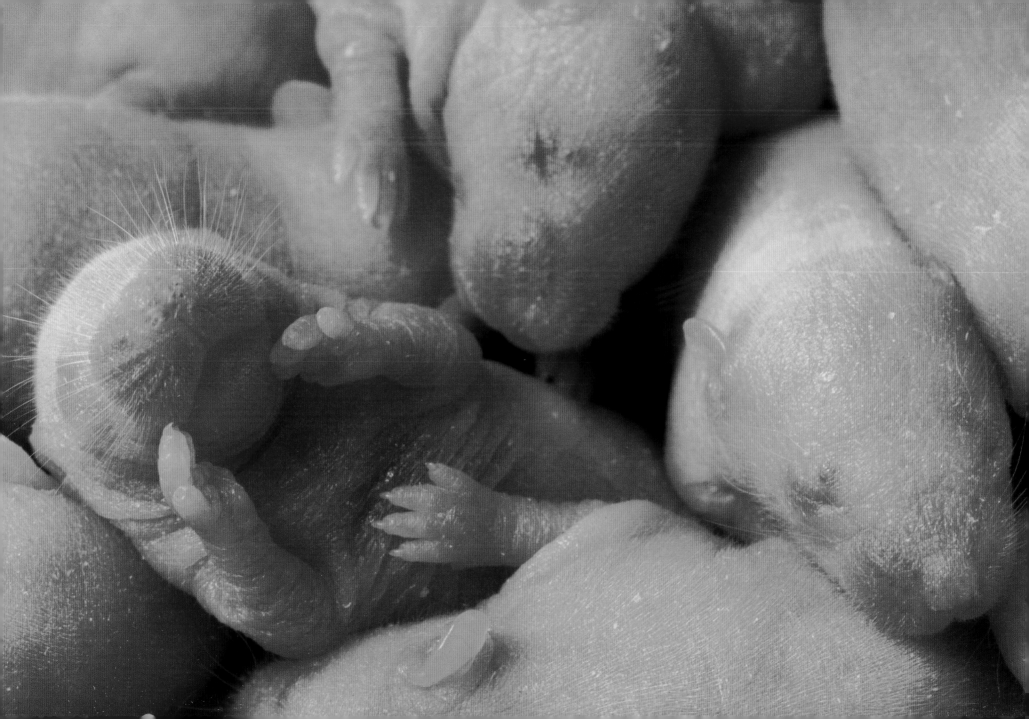

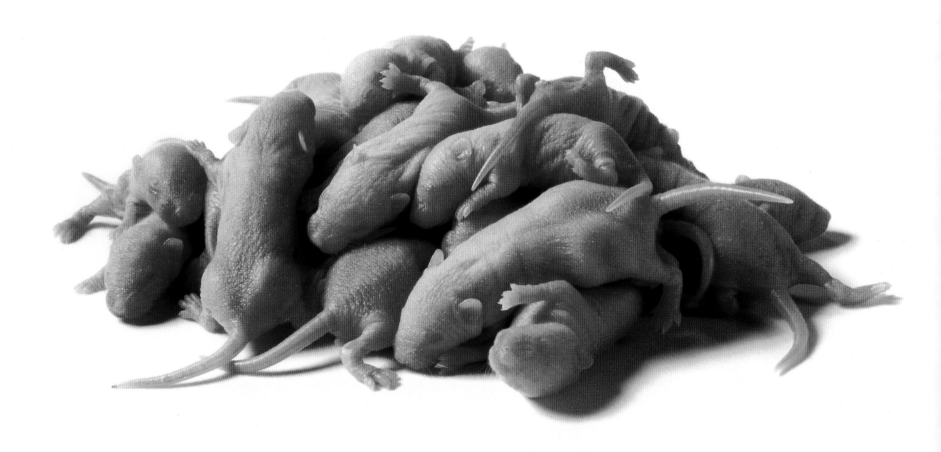

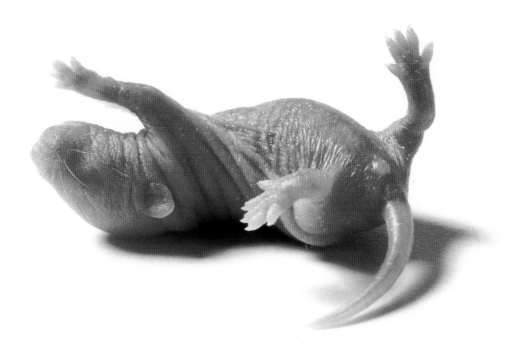

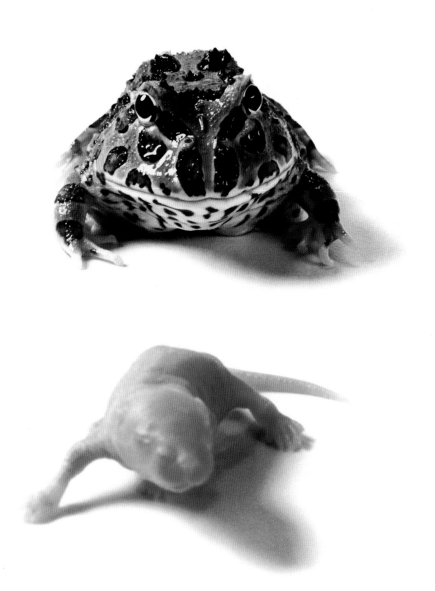

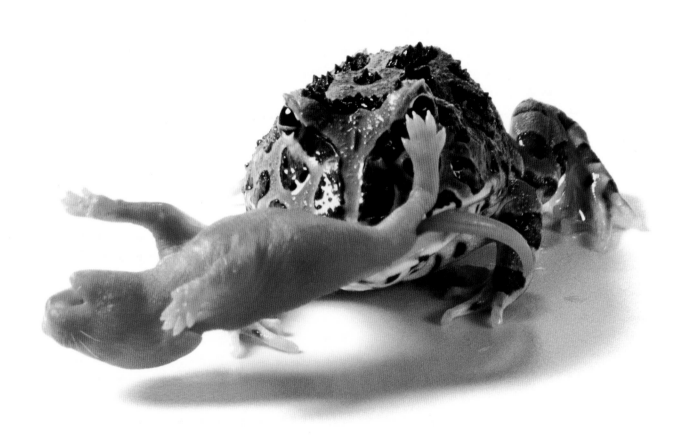

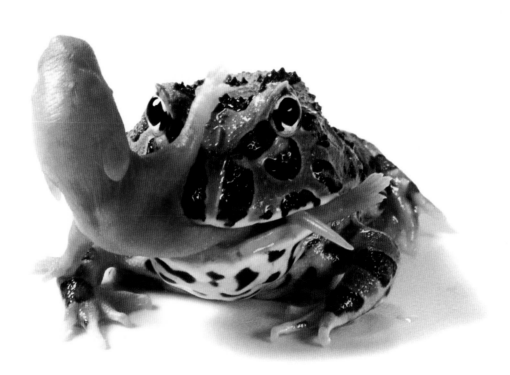

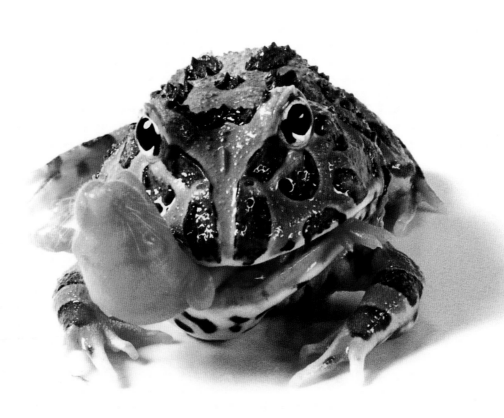

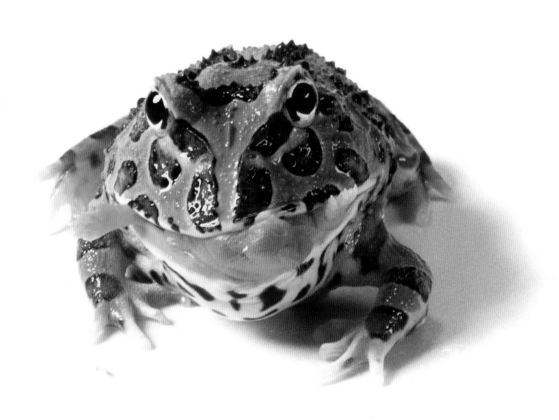

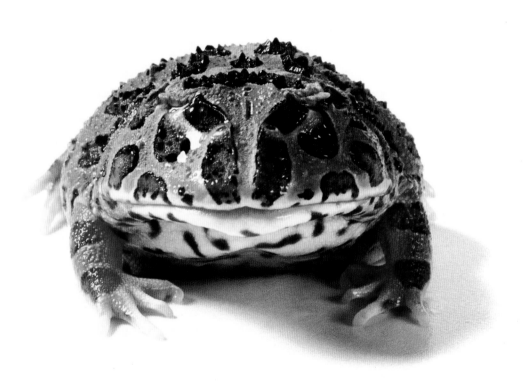

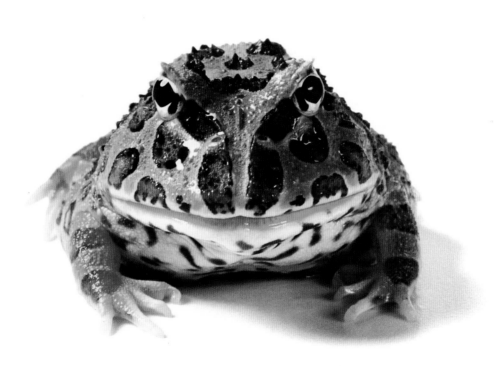

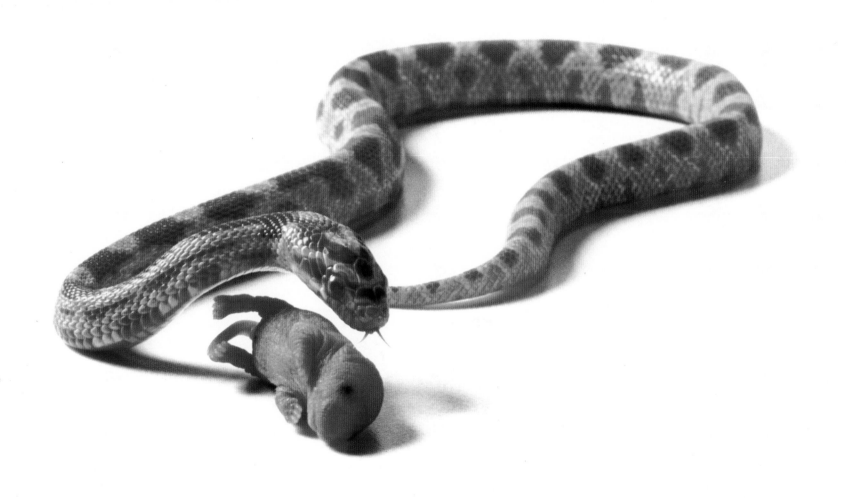

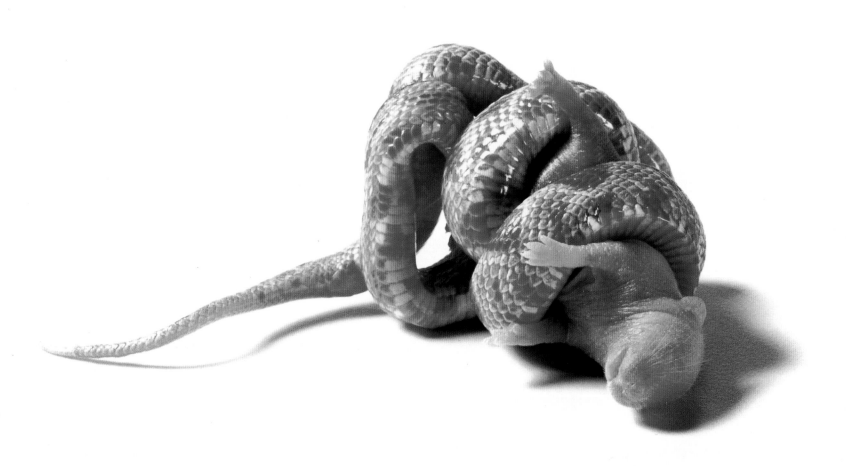

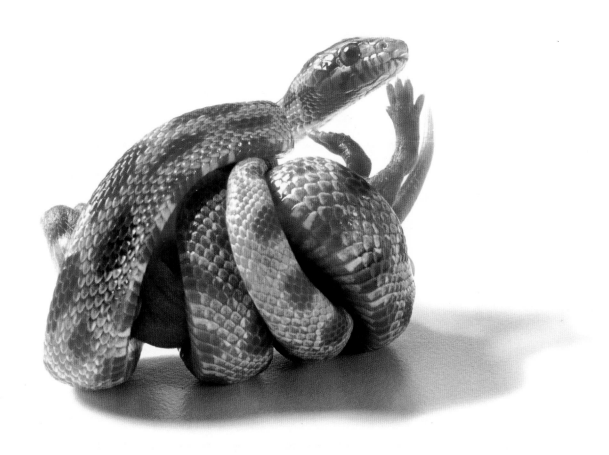

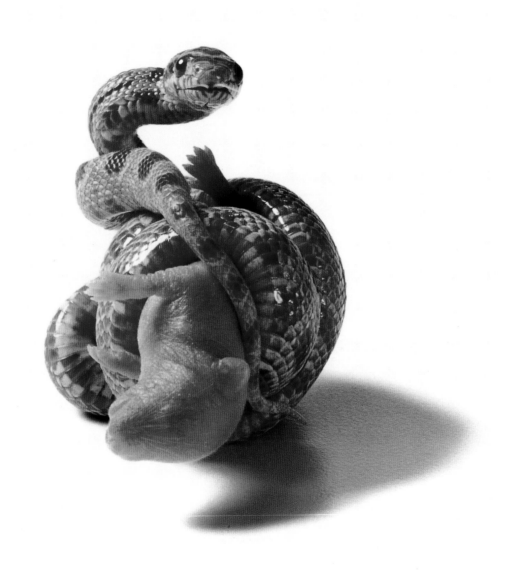

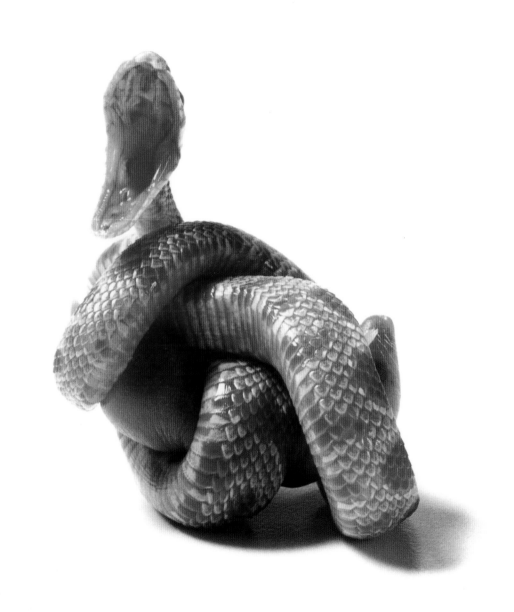

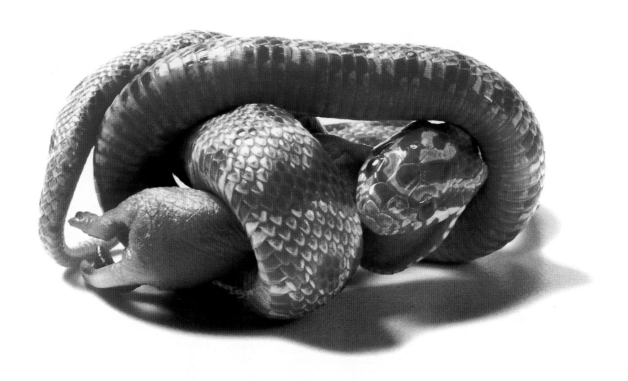

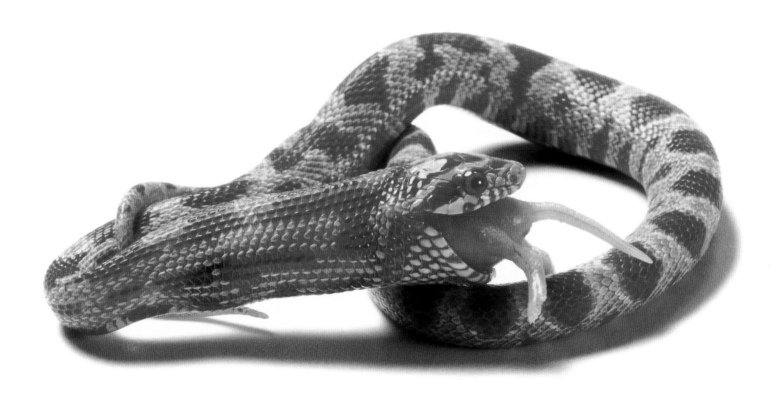

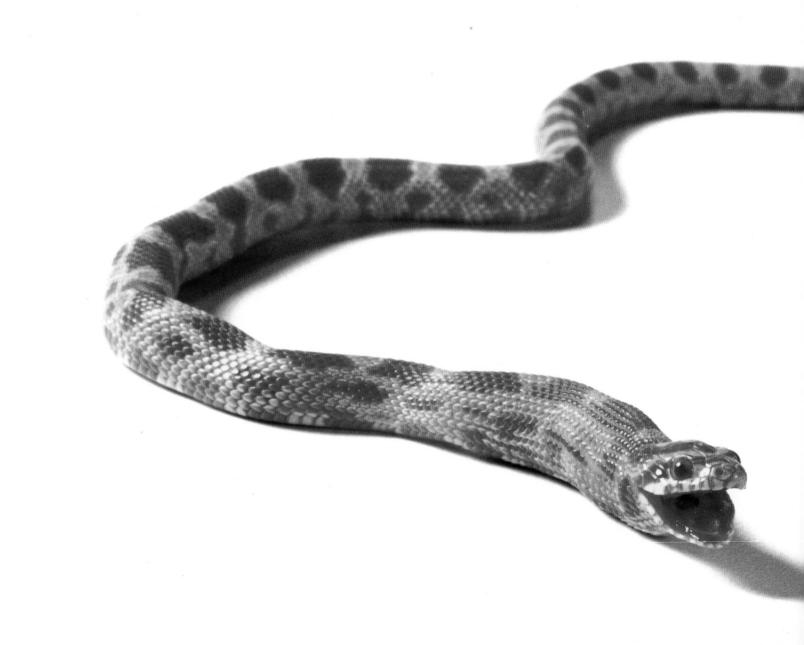

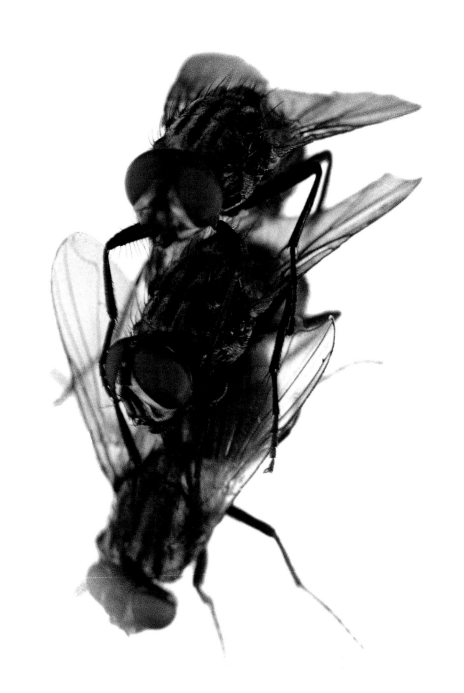

MICHAEL L. SAND: Your photographic work with animals started with flies. Why flies?

CATHERINE CHALMERS: I was interested in working with an animal that lives a parallel life in our own home. And I was interested in the fact that flies are so easily dismissed. You dust them off your windowsill or you chase after them with a fly swatter. That is the extent of most people's interaction.

I wanted to try to see what they are like, to see how they conduct their lives. What they do when they're hanging out. How they socialize. And, interestingly, over the four months that I observed and photographed them, I never saw them fight. They don't seem to be territorial.

MLS: It appears they engaged in group sex, but not fights.

CC: Oh, yeah. When a female was receptive she was inundated by four or five flies trying to mount her at once. And she would mate with many of them in a row. Other than that, they'd congregate, hang out, loiter.

MLS: Did they make a lot of noise?

CC: They'd buzz, but they weren't as loud as my crickets. And to my surprise the flies didn't smell. Just the sweet smell of their food, powdered milk and sugar.

MLS: Where did you get the flies?

CC: I ordered pupae cases from a biological supplier, which is the easiest form in which to

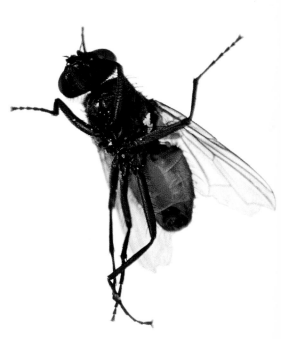

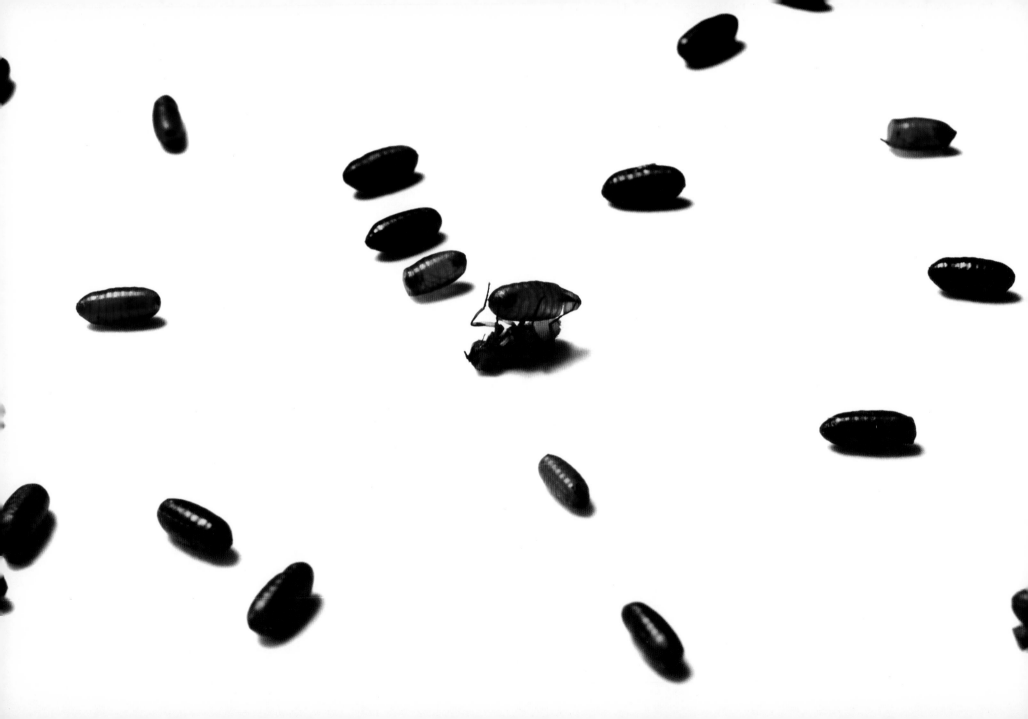

deal with them, as opposed to eggs or maggots. You can pour them into a terrarium, and in a couple of days they hatch. The population curved about every six weeks, which is roughly their life span. You see, they were not breeding as fast as they were dying of old age, because I kept the bottom of their cage too clean. I was hesitant, for obvious reasons, to let their cage become disgusting enough for a real population explosion.

MLS: And this work led directly into "Food Chain?"

CC: It did, because I saw the flies do so many great things, and I understood the importance of paying attention to the animals we classify as "lower life forms." I noticed, though, that with the flies I had missed two essential aspects of life—eating and dying. The flies ate and died at the bottom of the cage, and I photographed them up in the air, so as a result I missed those two things. And, as I repeated to myself "eating and dying," the two ideas got coupled together and I thought of eating and dying at the same time, which is basically one animal eating another while it's still alive, and that led to "Food Chain."

At first I was horrified by the idea of raising an animal to feed to another animal. It disturbed me that I was going to be governing life in that way. But when you think of how central food chains are to all systems in life, it makes a certain amount of sense. So, even though I was uncomfortable with the idea, and maybe because I was uneasy, I felt it was an important area to explore. Western society has become divorced from the act of killing the animals we eat. I wanted to see why.

MLS: How did it evolve from there? Did you know right away what animals you wanted to raise, what would be practical and what would be interesting?

CC: There were a number of problems. One—who eats whom? I'm not a zoologist; I don't even have a garden. So I didn't know how to piece it together. And the second problem was, what can you raise in the confines of a loft in New York City? A friend who is an entomologist at the American Museum of Natural History gave me a list of suppliers of live insects. So I started collecting catalogues, which were mostly for scientists. Some were agricultural, and they talked about which insects ate which pests.

I thought of a number of different scenarios for starting the food chain, until I saw the tobacco hornworm larva in the Carolina Biological catalog. I liked it because it was turquoise, and it wasn't poisonous, and it would eat tomatoes, which are readily available. After finding the bottom of the chain the rest fell into place. I knew I wanted to use a praying mantis, but I thought that it would be the top predator. When I found out that a tarantula would eat a praying mantis, the praying mantis slipped to the middle position and the tarantula became the top dog.

MLS: And did things go as planned?

CC: Not at all. Everything was out of whack. The caterpillars grew up, pupated, and turned into moths. The praying mantis egg cases hadn't even hatched. And the tarantula wasn't eating because it was about to molt. I went through two more life cycles of the caterpillars into moths, into caterpillars, into moths. I took six months to get the timing right.

It took a mini-ecosystem to raise praying mantises. You need fruit flies to feed them when they're babies, then houseflies, then crickets as they grow bigger. The stage when they're eating houseflies is the hardest. It takes hours to feed the whole brood, which are housed individually because they're cannibalistic. I had to capture one fly at a time from a big cage and transfer it to each praying mantis. I got so good at catching flies that I could even capture the ones flying free in my loft.

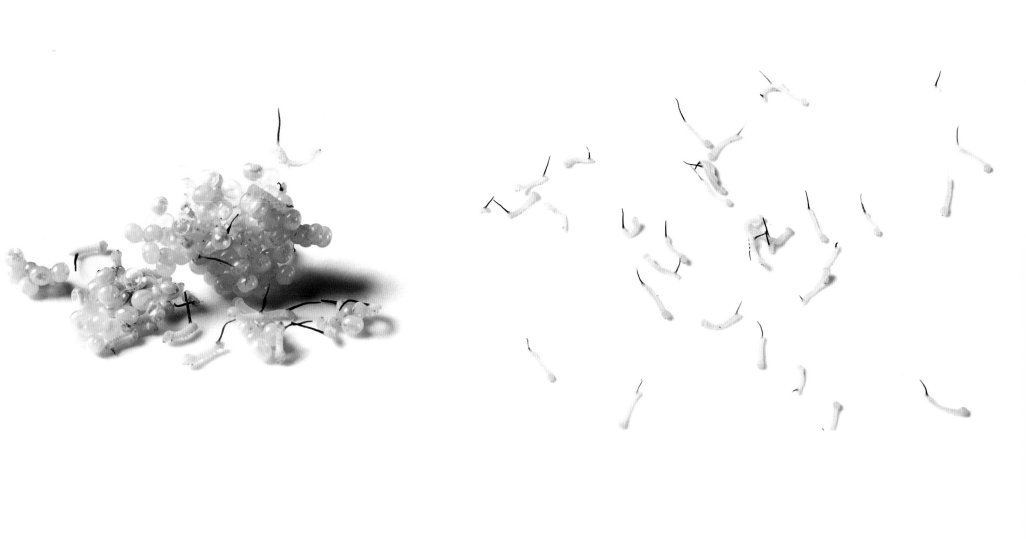

The first praying mantis I put on the set with a caterpillar was, to my horror, attacked by the caterpillar. I had put so much time into raising each praying mantis that the possibility of a caterpillar killing it was very upsetting. I quickly realized how subjective our ideas about death are. We so often root for the underdog, but when your underdog is abundant and bites, you think differently. I broke the two apart and waited another month for the praying mantis to mature.

Then, when I put the tarantula up on the set with the praying mantis, nothing happened. It's hard to know when a tarantula is hungry, and the one I was using was slow, docile, and wasn't hungry very often. The problem was that the praying mantises were getting big and would soon reach a size that might make the predator-prey scenario reverse itself. I had only one spider and didn't particularly want to lose it.

So I thought I'd better get a more reputable top predator. I hadn't spent six months of daily work raising praying mantises to have the project fall apart because of a finicky eater. So I got a frog. I put the frog on the set with a praying mantis, and boom, in two shots it was over. First you see a hungry frog facing the mantis, and then you see just a leg sticking out of the frog's mouth. [See front and back of book jacket.]

But I kept trying with the tarantula because my entomologist friend said the spider would enjoy the praying mantis, and needed a varied diet anyway. One time in the middle of the night, while I was watching Silence of the Lambs (which coincidentally used the same caterpillars), the tarantula ate the praying mantis. I stayed up the rest of the night taking pictures as it ate.

MLS: You went to the trouble of raising more praying mantises to photograph them having sex. You knew, I assume, of the legendary aspect of praying mantises—that the female might devour the male?

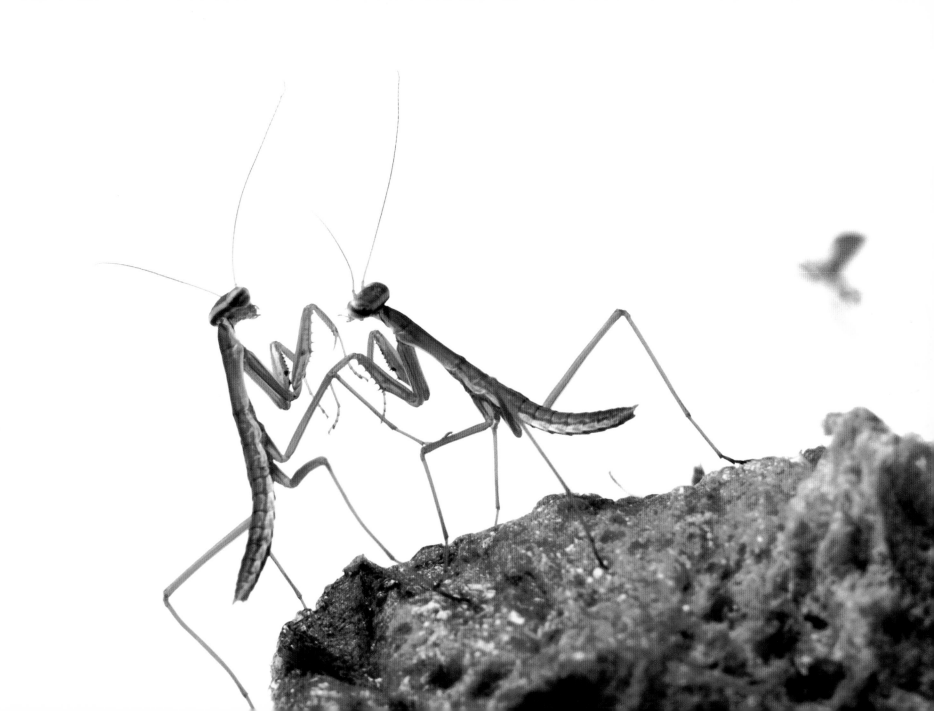

CC: Yes, but after many months of raising mantises I realized I didn't know a male from a female. I found an obscure pamphlet published in England thirty years ago by a couple whose hobby was raising praying mantises. To determine the boys from the girls you do the obvious: look under their skirts. You lift up the wings and count the segments on their abdomens. Males have eight and females six. After the last molt, you wait three weeks, heat the male up to 80 degrees, and put them together in a big space. They also said that if the female was well fed, she was less likely to eat him. But, it's not just a matter of male as meal. When she bites his head off she gets more sperm, according to one study I read.

The male was very cautious approaching the female. The female, for the most part, ignored him. He did most of the courtship. I thought of insects as having instantaneous sex. I stood there, camera ready, thinking it would be over in a flash. But not so with the praying mantis. They can stay coupled for hours. All my males got away unscathed, except one. After hours of being joined together she reached around, grabbed him by the neck and bit his face off. It took her another couple of hours to eat almost every last bit of him.

MLS: Why did you decide to use a plain white backdrop for these photographs?

CC: I had just photographed the houseflies in black and white. Flies don't have the same relationship to gravity that we do—up, down, sideways, they are comfortable in positions we are not. So flies floating free in an unspecified white space felt appropriate. It also took them out of the dirty world we associate with them, and out of our world too. While I was thinking

about doing "Food Chain," I knew I wanted a similar sort of feeling. I wanted the situation to be neutral, so you could see the animals and what they were doing.

MLS: It certainly focuses attention on them. It removes all distraction, and it also dissolves the borders that exist between humans and animals in a natural environment.

CC: I didn't even consider putting them in a natural setting. The tomato is not on a vine, the praying mantis is not on a bush, and so forth. But, had I done this, the pictures might look like nature photography, which I think sometimes accentuates the distance between them—the animals living out there in the wild—and us, living inside our protective walls. I was interested in removing that distance. I wanted to interrupt the relative comfort of "they're there and we're here."

"Food Chain" is, after all, only a simulation of what goes on in the natural world. In actuality, the four animals originally come from very different places and would never have met if it weren't for human intervention.

It used to be that humans were more exposed to the processes of nature. But, besides seeing animals on TV and in zoos, our interaction with them has whittled down to domesticates, like dogs and cats, and scavengers, like roaches and rats. In order to experience a chain of life I had to re-create it myself.

MLS: Isolating these creatures in a pristine white space also plays with scale in an interesting way. These animals appear so much bigger than they are in real life.

CC: To be taken seriously, size helps. If insects were the size of dinosaurs our relationship to them would be vastly different. Creatures smaller than our feet tend to be stepped on. If you take a newborn mouse that's an inch long and you make it twenty inches, it looks like it could be the fetus of many species. Even human.

MLS: The newborn mice do look like fetuses. They exude defenselessness, don't they?

CC: It's as if they shouldn't be born yet. They are completely defenseless, yet they, of any animal, could certainly use some weapons. They are the mainstay of so many diets. Frogs eat them, snakes eat them, birds eat them, spiders eat them, cats eat them. I call them "nature's Cheerios."

MLS: Caterpillars seem vulnerable like that too.

CC: Caterpillars have more defenses, though. They bite and many are poisonous. Baby mice can only squeal. Tobacco hornworm larva, the species I used, have a horn off the back, leading a predator to attack the tail end. Then the caterpillar loops around and bites the attacker. Certain caterpillars that live in the rain forest make a noise which attracts ants. They call the ants to live with them to protect them from wasps; in exchange the ants get sustenance from the caterpillar's body.

MLS: Which also challenges the idea that it's every creature, or every species, out for itself. Do you ever think about why the pinkies are so defenseless? Why they're "nature's Cheerios?"

CC: Where to start with the question of why? The fact that mice can have so many babies over a lifetime answers the problem of so few surviving.

MLS: Does the mother value them less? Does she feel less of a need to protect them than other parents do?

CC: No, I think she values them like other mammals do. Although sometimes she'll eat one, usually the first one out. The females seem to like having babies to tend, and when they don't, they'll kidnap another mother's babies. Then the mother steals them back, and this can go back and forth for quite a while. When several mothers have babies at the same time, they'll pile them all together.

MLS: Why do they pile them?

CC: The babies like to be next to each other for warmth and protection. They huddle together, and if a few get separated, the mother puts them back together.

MLS: Does it ever get violent?

CC: The only real violence, horrible, horrible butchery, is with males.

MLS: Males on males?

CC: Yes, brothers that get along, come of age, and turn on one another. They have to be separated. The most stable situation is several females and only one full-grown male. One time, though, a male butchered all the babies. Not just killed them, but dismembered them and threw the body parts around the cage. It was very upsetting. But, you know, after that, I thought, if they can mutilate their own, I don't feel so bad feeding a few to my snake.

MLS: Have you had any problems with animal-rights activists?

CC: Working with animals can elicit extreme and often opposite reactions. I try to provide my animals with a healthy life, and I never personally harm a thing. But my snake, frog, and tarantula are not vegetarians. Sprouts and tofu don't appeal to them. Either they die of starvation or else a cricket, mouse, or worm dies to feed them. That's the basics of nature—there's no way around it. During an interview I did on National Public Radio, for Ira Glass's "This American Life," the interviewer wanted to record me working. At that time I was photographing "Pinkies," so I put Pumpkin, my baby corn snake, on the set and gave it lunch—a baby mouse. The mouse squealed while it was being constricted and the show included it. Ira said he got several calls from animal-rights activists complaining about a mouse dying on a radio show.

MLS: I guess it's not surprising that it was the mouse that people had trouble with, as opposed to a caterpillar, for instance.

CC: Sure. It's completely subjective. Caterpillars are insects and we seem to have the least amount of affection for them. But if insects were wiped off the face of the planet—and fortunately the billions we spend on insecticides haven't succeeded—our days would be numbered.

In the case of the caterpillar and the praying mantis, the caterpillar's point of view is, "Hey, you know, I want to live to be a moth. Don't eat me." And the praying mantis says, "Look, I'm hungry." These are two opposing positions. Then we come along with our own opinion. Praying mantises have big eyes, more personality, and a head that moves on a neck, as ours does. Caterpillars have scant expression, are plentiful, and eat our crops. So we root for the praying mantis. But, in general, the animals we like and actively try to protect are much less abundant than the animals we work hard to eliminate. The way we live radically increases the very species we hate the most, the so-called weed species, the things that live off of us.

MLS: It also applies to our judgment about what we should and shouldn't eat, doesn't it?

CC: True, but even when we don't eat meat, we're still displacing ecosystems by clearing land and planting crops. So even if you're eating corn, something's dying for you to eat that corn. The animals that lived on that land for starters, and then all the ones who try to eat that corn instead of us. There's really no innocence in eating, no matter how you chase it around.

MLS: Were there times when the animals did not behave in a way that you anticipated?

CC: I was surprised how easily the predator-prey relationship could be reversed. I didn't want to set up a situation that would be against what might happen in nature. So I built a big, open set, and if the animals didn't want to be there, they could leave. And some did.

I was also amazed at how many times my frogs lunged and missed their prey.

MLS: There is that sequence in which a large praying mantis faces off with a small toad.

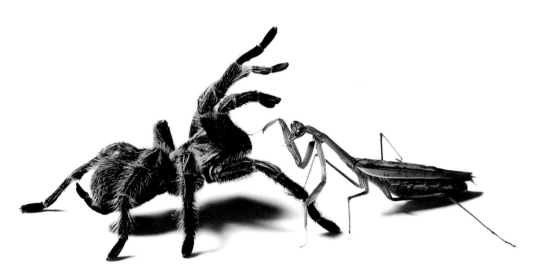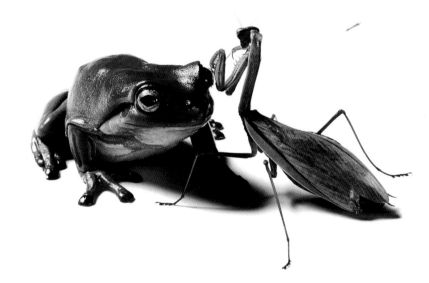

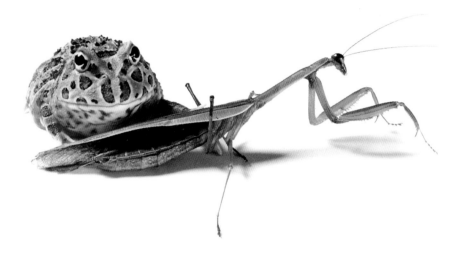

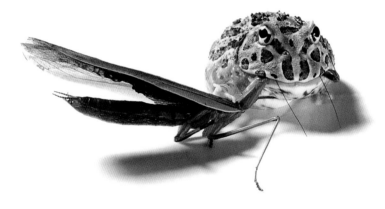

CC: One of my full-grown, female praying mantises was dying of a wound inflicted by a male when they were mating. Of course, it is the female who is supposed to attack the male.

She was clearly on her last legs so I decided to feed her to my little garbage can of a toad that ate everything in sight, no matter how big. He went for her immediately.

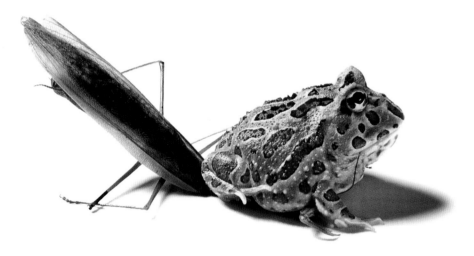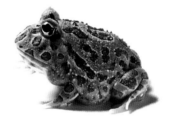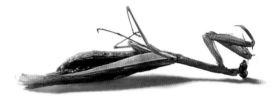

He kept her in his mouth but couldn't swallow her, then spat her out. Then sat on her head.

And then he turned and hopped away.

MLS: You have photographed the skin left behind when a praying mantis molts—which you call a "ghost."

CC: They molted many, many times before reaching adulthood, at which point they got their wings and became sexually active. After that they didn't molt again.

When molting they hung upside down, and slid out the top of their skin. It was a critical time and the enclosure had to be kept moist. The praying mantis came out looking fragile and transparent and the skin looked like a perfect clone. I collected these and had an army of ghosts, kind of like China's terra-cotta warriors.

Many of the animals I raised were invertebrates, meaning they wear their skeleton. When my tarantula molted she flipped on her back, looking rather dead, and slowly slithered out of her furry body. When she came out, she looked like a brand new spider. She was so beautiful and the colors were very vibrant.

MLS: Imagine if we could molt!

CC: All those plastic surgeons would be out of business. And many orthopedics too. If the spider breaks or even loses a leg, she can regenerate it the next molt. But it is also a very vulnerable time and many animals die in the process, either by being tangled in their skin or by being attacked. They are defenseless while molting.

A couple of my praying mantises emerged twisted and horribly deformed. One somehow got its arms crossed in the process. It died because it could no longer catch or eat its food.

MLS: What was the hardest part of this whole project for you to deal with?

CC: The hardest part was the very heart of the project: seeing a living thing being eaten alive, and choosing the animal to have that fate.

Specifically, I had a hard time feeding full-grown mice to my rapidly growing snake. They knew what was going on, they saw the snake coming, and they were scared.

After a while, though, I realized that the real problem with the mice was not so much the horror we have of a mammal being eaten by reptile, or the burden of choosing who lives and who dies, but overpopulation. I had huge population explosions. Even though I had seven predators, my mouse community was still increasing exponentially.

MLS: Which is a problem in the natural world too, I suppose.

CC: Thankfully there are predators.

MLS: How did you decide where "Food Chain" would end?

CC: Three stages is enough to get the idea across. I also wanted to stay with the smaller creatures. My interests are with the animals that make the world go round but get little attention.

MLS: The frog eating a baby mouse was very unexpected, almost uncanny, to me. We don't tend to imagine that frogs eat mice.

CC: There are many reasons that it seems improbable. Snakes are associated with evil, while we tend to think of frogs as cute. But some frogs are poisonous and quite nasty. We imagine frogs eating insects, or fish, and we don't have a problem with that. In reality, frogs will eat all sorts of baby animals too.

MLS: You photographed some of the survivors from your work with pinkies.

CC: The photographs in "Pinkies" mask the reality of what happened to the baby mice. It looks like all the babies were eaten. But, of course, the opposite is the case. Ninety-nine percent survived. I had an arrangement with a pet store; they took my weaned babies and in exchange I'd get more mouse food. They were happy because they sold my mice for twice the regular amount, since they were fancy, with multi-colored coats.

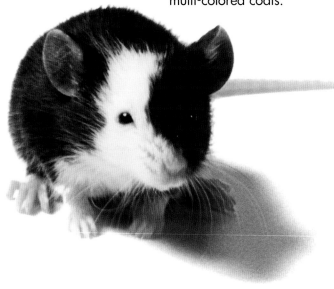

I decided to photograph the multitude of survivors and put them on the set for a group portrait. What chaos that was. They were running all over the place. I took some individual shots too. In the scope of it all, mice are doing just fine out in the world. They're not in danger of becoming extinct.

They're not losing the struggle.

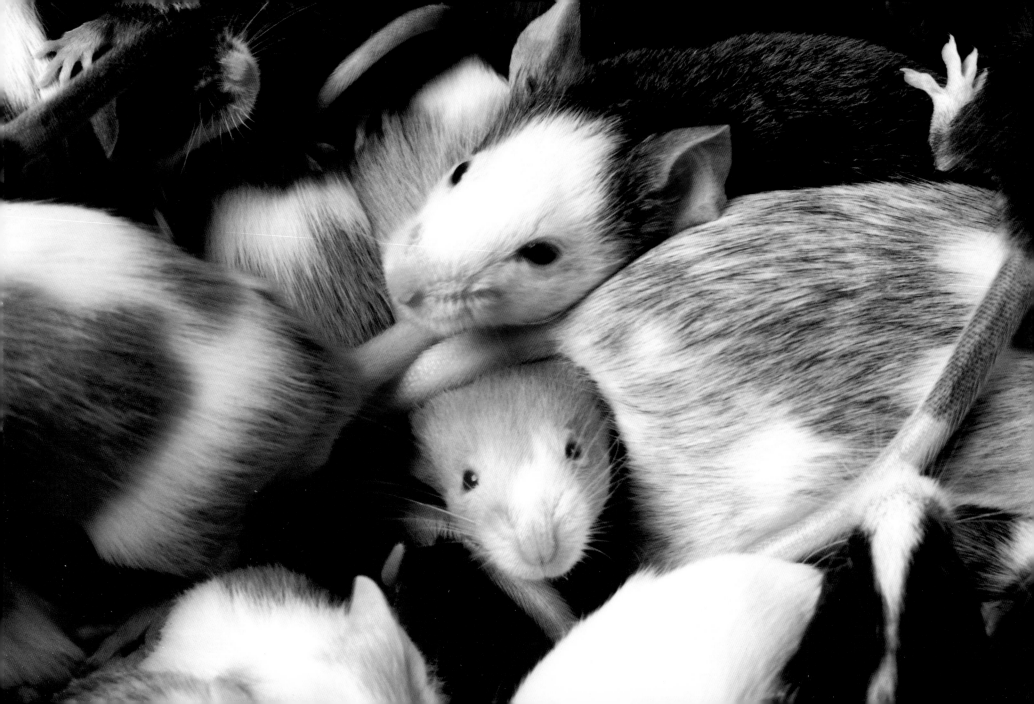